FOOD PHOTOGRAPHY
AND STYLING

Ꙡ

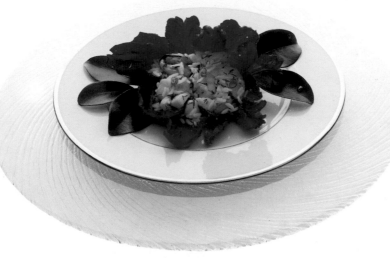

PHOTO © NED McCORMICK

FOOD PHOTOGRAPHY AND STYLING

John F. Carafoli
WITH ROSALIND SMITH

AMPHOTO
An Imprint of Watson-Guptill Publications
New York

Edited by Robin Simmen
Designed by Jay Anning
Graphic production by Hector Campbell

First published in 1992 by Amphoto, an imprint of Watson-Guptill
Publications, a division of BPI Communications, Inc., 1515 Broadway,
New York, NY 10036.

Library of Congress Cataloging-in-Publicaton Data

Carafoli, John F.
 Food phototography and styling : how to prepare, light, and photograph
delectable food / John Carafoli.
 p. cm.
 Includes Index.
 ISBN 0-8174-3898-X : $32.50. — ISBN 0-8174-3701-0 (pbk.) : $22.50
 1. Photography of food. 2. Food—Pictorial works. I. Title.
TR656.5.C37 1992
778.9'3—dc20
 92-16258
 CIP

Manufactured in Malaysia

2 3 4 5 6 7 8 9 / 00 99 98 97 96 95 94 93

*With gratitude and understanding of the force and energy
that inspires and sustains me in my work.*

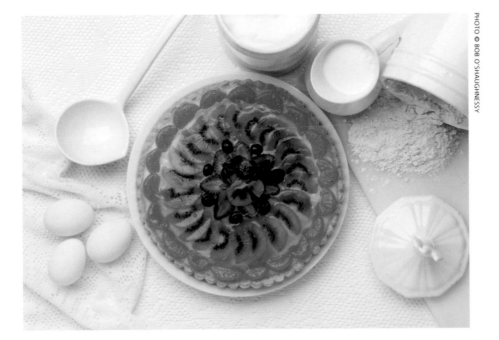

PHOTO © BOB O'SHAUGHNESSY

The need for a book on food styling became clear to me when I first entered the field and discovered that no information on the subject was available. I would like to give special thanks to all the photographers who've hired me. Through those experiences I grew and learned a special trade.

I would also like to thank Rosalind Smith for her support in making the book's concept a reality. She helped extract information from me that I didn't even know was there.

A personal thanks goes to my friend Sara Giovanitti for designing the proposal that sold Amphoto on the project.

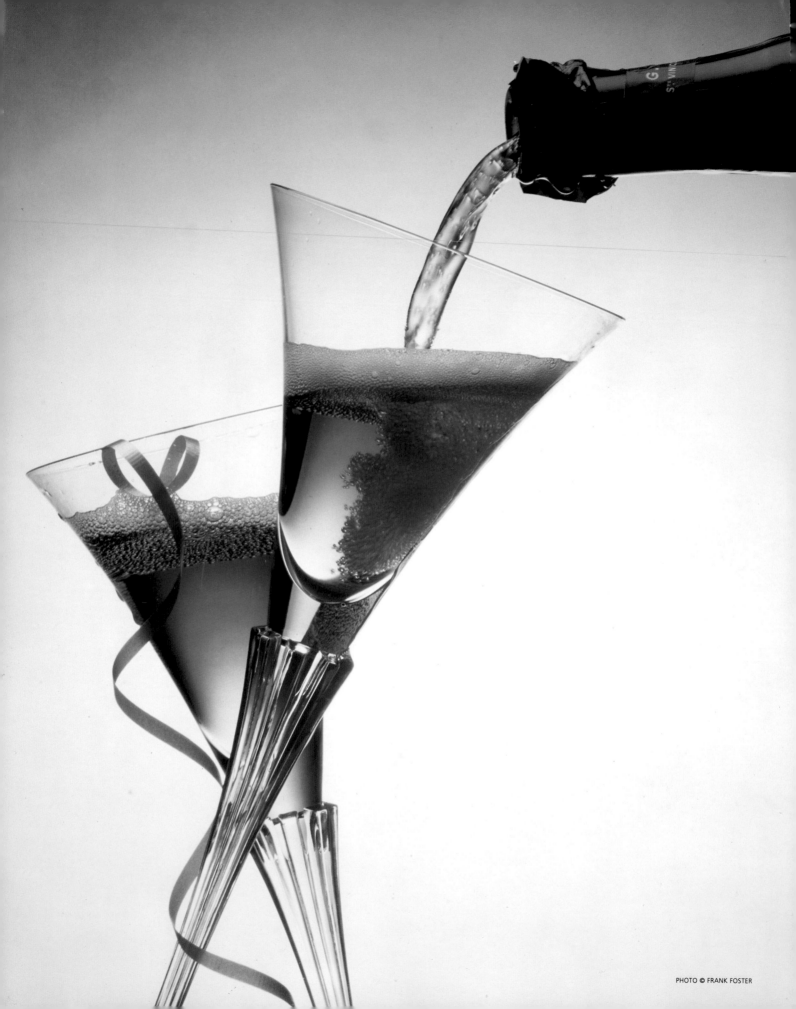

Contents

Introduction

Having a well-organized tool kit and kitchen is a major key to successful food styling.

PHOTOGRAPHING FOOD successfully requires special techniques and skills to enhance the way food looks on film. A food stylist's job is to make food look appealing, appetizing, and natural. The stylist must have a good knowledge of food preparation and chemistry, and must also possess a strong sense of visual design. Until recently, most food stylists were home economists. But over the past few years, people with backgrounds in design have introduced a new dimension to the field, bringing a more graphic perspective to the business of creating food for the camera. ◙ Styling food for photography, whether for still shots or television, is meticulous, precise work that demands patience. Though some people think food styling is a glamorous career, it is mentally and physically demanding, and involves hours of intense concentration. Large projects featuring food usually require a professional stylist. Photographers who try to shoot these alone probably don't know enough about the chemistry of food, how different foods react under lights, or what shortcuts exist for preparing food for the camera. Nonetheless, many of the techniques in this book could be recreated by a photographer and an assistant without using a stylist. ◙ The working relationship between a photographer and a food stylist should be extremely close. Photographing food is a team effort, and the photographer is usually the leader. He or she hires the food stylist (although sometimes the photographer's client requests a certain stylist). There must be mutual trust and respect between the photographer and stylist, along with a shared ability to solve problems. In the end, the way they work together makes or breaks the shot. ◙

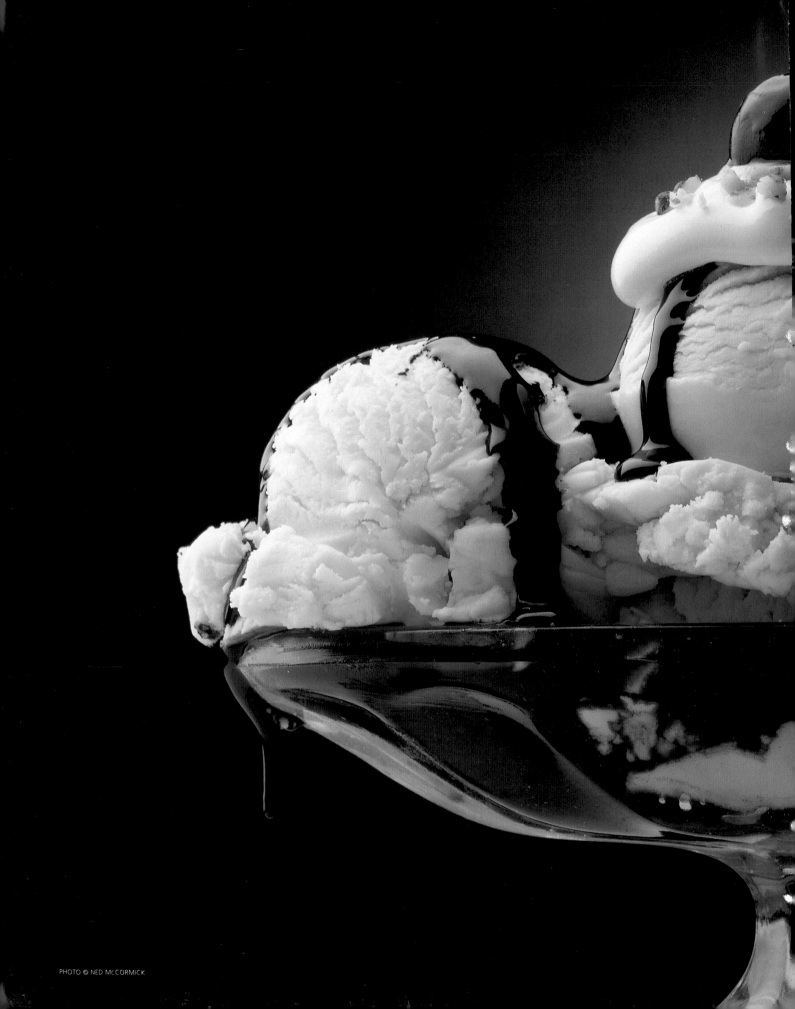

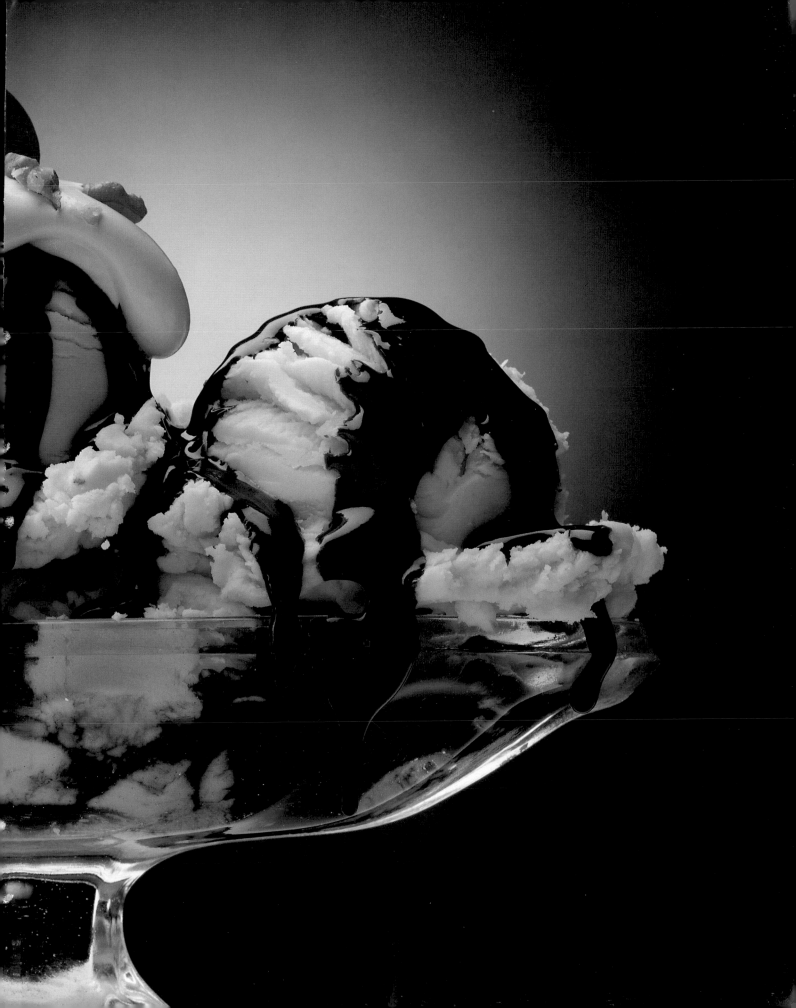

Introduction

The information in this book comes from my own, hands-on experience. My earliest work with still photography was as creative director for several ad agencies and publishing houses in Chicago. Always interested in food, I went to Madeleine Kamman's Cooking School in Boston and started writing about food for *The Boston Globe.* Producing regular features for the paper, I hired photographers to illustrate articles, and they began to hire me to style other jobs. I was introduced to food styling as art director for *Sphere* magazine; it later became *Cuisine.* Since then, my food styling career has been up and running.

What I offer in this book are creative solutions to many of the problems I've encountered in the kitchen and on the set. Keep in mind that there are no hard and fast rules for any of the situations described here. My book is intended to be a working guide for photographers and everyone concerned with food styling for the camera. Use the following information as a springboard for problem solving on future shoots. Whether you're a food photographer or a stylist, I encourage you to bring your own sense of style, creativity, and ingenuity to all the food-photography challenges you encounter.

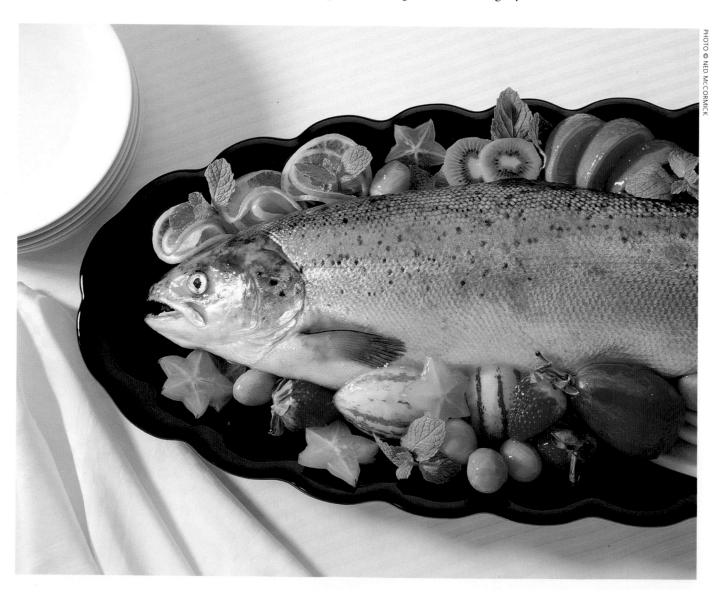

Tools of the Trade

When I first began working as a food stylist, I carried all my equipment in a small, metal, fishing-tackle box. As my jobs became more demanding and I needed more room, I switched to a large, lightweight, plastic toolbox.

I use large canvas bags to transport groceries and other loose items to the studio. My knife kit, with pockets for knives, tools, and accessories, is custom designed to roll up and be carried separately by its handle.

It is always a good idea to check in advance with the studio where the photography is being shot to find out what cooking equipment is kept on hand there. Sometimes not much is available. Be prepared to bring with you such things as pots and pans, a food processor, and any other special equipment needed for a particular shoot.

Here are the contents of my toolbox: Tray, clockwise from the left: Spud-Nu (fruit and vegetable freshener), Crazy Glue, pastry tip, Kitchen Bouquet (gravy coloring), Elmer's Glue, wire whip, baster, glycerin, another pastry tip, and syringe. In the foreground, counterclockwise from the left: can opener, spatula, a variety of straight and safety pins, eyedropper, toothpicks, paintbrush, Q-tips, tweezers, straw, three ice-cream scoops, two Zeroll scoops, three sprayers, ice-cream spade, and olive oil.

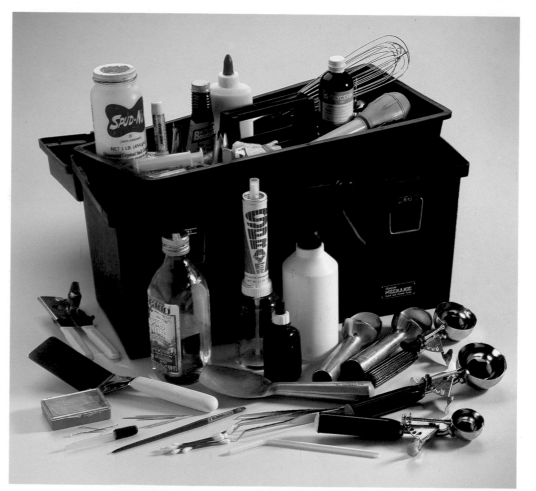

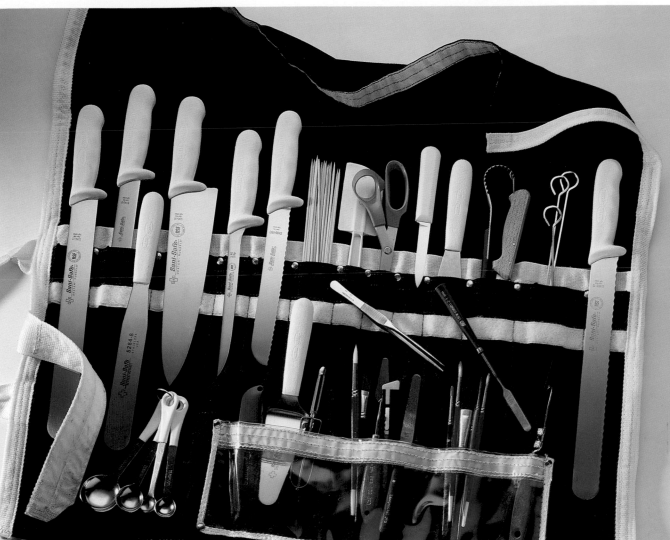

The contents of my knife kit: Top row, from the left: roast-beef slicer, lunch slicer, spatula, cook's knife, boning knife, bread knife, wooden skewers, scraper, scissors, paring knife, 6" frosting spatula, butter curlers, paring knife, metal skewers, and serrated beef slicer. Bottom row, from the left: measuring spoons, X-Acto knife, pie knife, vegetable peeler, paintbrushes, artists' palette knives, more paintbrushes, and lemon peeler. Slanted in the middle, from left: tweezers and palette knife.

BASIC EQUIPMENT FOR A
PROFESSIONAL FOOD-STYLING KIT

ASSORTED BRUSHES

Basting brush

Paintbrushes, various sizes

Toothbrush

Pastry brush

KNIVES

Chef

Bread and cake slicer

Paring

Boning

Carving

Corer

Vegetable peeler

X-Acto knife with extra blades

SPATULAS

Wooden and metal

Palette knives (found in art
supply stores)

Pancake/slotted/lifting

SPRITZERS AND SPRAYERS

Atomizer (small)

Spray bottle (medium)

Assorted eyedroppers

SCISSORS AND SHEARS

Kitchen shears

Surgical scissors

Poultry shears

SKEWERS

Bamboo and metal

Pins, both common and T-pins

Barbecue skewers

Dental and sculpture tools (for
detailed work)

Straws

Toothpicks

TOUCH-UP AND CLEANING ITEMS

Q-tips

Long cotton swabs

Paper towels

Glass cleaner

FOOD STUFFS

Glycerin

Kitchen Bouquet

Corn syrup (light)

Oil (light)

Food coloring

Cornstarch or arrowroot

Flour

Plain gelatin (or other thickener)

Vegetable and fruit freshener

Lemon juice

ICE-CREAM EQUIPMENT

Scoops (assorted variety and sizes)

Spades

Hammer

Small bowls

Heavy gloves

MISCELLANEOUS ITEMS

Timer

Putty or clay (to use to support
food and keep it in place)

Funnels (assorted sizes)

Bottle opener

Can opener

Photographer's gloves

Meat thermometer (instant)

Needle and thread

Nonstick fry pans (small, medium,
and large)

Matches

Thin wire

Band Aids

Ruler

Tape measure

Grease pencil

Measuring cups

Wire whisks

Hand-held electric beater

Pastry bag with assorted tips

Dental floss

Propane blowtorch

Tweezers (best source: a jewelry
supply house)

Tongs (small, medium, and large)

Spaghetti tongs

Drinks

Spritzing and spraying a glass with a mixture of glycerin and water creates a chilled, refreshing look for any drink. This technique also works on jars, cartons, and aluminum cans.

PHOTOGRAPHERS AND STYLISTS often need to create a cool, frosted, appetizing look for drinks, bottles, cans, and beverage cartons. The techniques for doing this are the same for all surfaces. I always mix a fifty-percent solution of glycerin and water for spraying the surface because the glycerin helps me control the formation of drips. Styling how the ice looks inside a drink is always a challenge. Using real ice can create headaches because it melts, thereby adding more liquid and changing the drink's consistency. There are many solutions to this photographic problem. Probably the most popular is to use artificial ice cubes, available from "special effects" suppliers (see page 141 for manufacturers and retailers). You can have ice cubes made to order or buy them ready-made in sets. Prices vary depending on their size and material. There are two kinds of artificial ice cubes—glass and acrylic—and they come in every available shape and texture: for example, clear, cracked, frosted, and bubbled. Some glass cubes are blown hollow so they will float. Frosted, cracked cubes, while more authentic looking, are not as popular as clear ones as these help create a cleaner, crisper-looking drink. Also, acrylic is brighter than glass, and the sculpting on acrylic ready-made cubes is generally more interesting. The disadvantage to working with acrylic cubes is that they are sometimes damaged by alcoholic beverages. Crystal Ice is another product used to simulate crushed or cracked ice. An aqueous, high-water-absorption polymer, it is supplied in granules to which water is added in varying amounts. (Much to my surprise, I've found the same substance in florist-supply shops; it is also used for rooting plants.) Ice Powder is also an aqueous, nontoxic, polymer, but it is used to simulate frost as well as ice. Its low-luster appearance is similar to frost particles, snow-cone slush, and shaved ice, and it dramatically resembles the real thing.

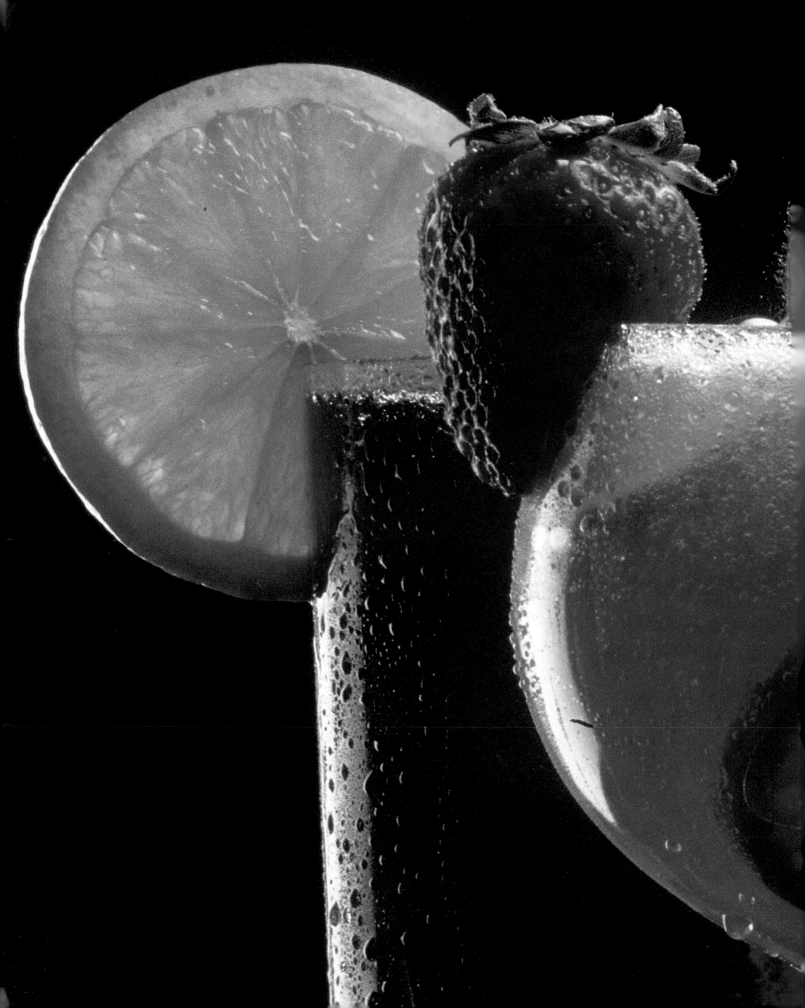

Drinks

The photograph on the last two pages was used in *Prelude* magazine's food section. It was shot with a dark background to give it more graphic impact. The theme of the feature was "summer drinks." Jack Richmond, the photographer, and I wanted to capture the effervescence of the beverages and create a frosted look for the entire shot.

First, Jack and I went over the layout: a spread of three glasses garnished with an orange slice, a slice of Kiwi fruit, and a strawberry. Then we set up glasses on a black, velvet-covered tripod, and Jack arranged banklights overhead and to the left of the still life, adding a spotlight behind the scene to backlight the fruit garnishes and make them appear transparent (see diagram). We used acrylic ice cubes because they are easy to position in a glass and don't melt, thus giving us more control over the shot.

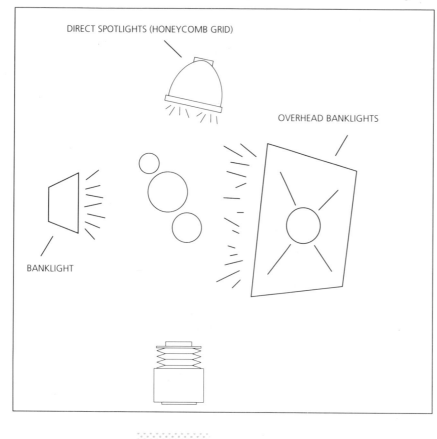

DIRECT SPOTLIGHTS (HONEYCOMB GRID)

OVERHEAD BANKLIGHTS

BANKLIGHT

JACK RICHMOND

Jack Richmond is a graduate of business school and the California Art Center College of Design. He has been a major figure on the Boston photography scene since 1977. Although he is a generalist, he has worked with most of the country's major food manufacturers, including Kraft Foods, Knorr Swiss Soups, Breyer's Ice Cream, and Ground Round Restaurants.

COOL AIDES

by Tony Manfield

Seasonal sipping guaranteed to please parched palates

Britain's Queen Victoria would not have been amused! The spectacle of two modern-day Colonial rustics peddling her favorite summer drink as "California Cooler" would surely have arched the royal eyebrows. Not that the beverage she royal personage imbibed was exactly the same. "Hock & Seltzer," as it was known to Victoria and her loyal subjects, was a simple mixture of Rhine wine and seltzer water with a slice of fresh lemon. "Hock" is derived from Hochheim, a scenic German village in the heartland of Rhine wine country. Yet the principle of combining wine, carbonated water and citrus flavoring to make a summer pick-me-up is identical.

Perhaps her heart would have warmed towards the homey Frank Bartles and Ed Jaymes had she learned of the great empire of thirsty Americans they have conquered over the last five years. It is estimated that in 1986 "coolers" accounted for over $1 billion of beverage sales in the U.S. There are currently more than 100 different varieties basking under such copywriters' fantasies as "California Splash," "Catalina Cooler," and "Sausalito Sling," to name a few.

Although this "pop" wine has achieved staggering commercial success, its value in gastronomic terms remains in some doubt. A scientifically formulated combination of white wine, citrus juices, sweeteners, preservatives, and carbonation, "coolers" have been variously described by their critics as "bug juice for grown-ups," "alcoholic Kool-Aid," and "Gatorade with a kick." Even a trade report appeared to damn the taste value of coolers with faint praise by stating: "At present, the quality of the wine [used] is not a factor in customer appeal."

Fortunately for those with more sophisticated palates seeking thirst-quenching refreshment in the dog days of summer, there are more satisfying wine-based alternatives.

Since Spain gave birth to the delightful summer cooler known as Sangria, Spanish red wines such as Rioja, Valdepeñas, and Penedes seem to provide the best base. But most red wines are acceptable alternatives. This recipe is easy to make and even easier to consume.

1 quart of red wine
Juice of 1 lemon and 1 orange
1 sliced orange
1 sliced lime
1 sliced lemon
1 tablespoon of granulated sugar
1 quart of club soda

Mix the wine, sugar and juice. Pour the mixture over ice into a glass pitcher and add the soda and fruit. Mix thoroughly again. (Substitute two full shot glasses of Grand Marnier or Cointreau for the sugar to add a touch of class.)

If you really want to titillate the taste buds, try this "Gourmet" version of Sangria:

1 quart of red wine
1 lemon
2 bananas
1 orange
½ cup of granulated sugar
½ cup of water
¼ teaspoon of cinnamon

Boil the sugar and cinnamon in the water for five minutes, stirring continuously. Allow to cool. Peel the bananas and orange. Thickly slice all three fruits. Cover the fruit with the cooled syrup and chill overnight. Fill a glass pitcher ½ with ice, then add the marinated fruit, ½ cup of the syrup, and the wine. Mix thoroughly and lightly mash the fruit.

In Colonial days, summer refreshers enjoyed great popularity. Given the physical hardships and the absence of air conditioning that our forefathers endured, this is not difficult to understand. Here is a recipe for Peach "Sangaree," a Colonial variation on the Sangria theme.

½ cup sliced peaches
2 tablespoons of lemon juice
3 tablespoons of sugar
pinch of cinnamon
1 whole allspice
¼ cup of red wine
Club soda

Combine and mix all of the ingredients well except the club soda. Chill for one hour. Strain into a tall glass and add club soda.

Other beverages of note in colonial times included Mann, Meridian, Bogus, Bomba, Rambo, Rumbullion, Rattleskull, Tiff, Toddy, Sampson, Stone Fence, and Whistling Belly Vengeance. Some of these evidently packed more of a punch than "Sangaree."

One of the simplest summer sippers to prepare and serve is named after French World War II hero Canon Kir. He led the guerilla movement known as the "Maquis" against the Nazi occupation forces in Dijon, home of the famed mustard. Kir is credited with devising the refreshing combination of "crème de cassis" and white wine whose taste bears his name. The tangy, rich fruit flavor of the blackcurrant-based "crème de cassis" provides a perfect foil to the astringency of the dry white wine. Whether this libation gained its popularity throughout France as a result of Kir's wartime exploits or its appeal to the Gallic palate, we will never know. Whatever the reason, the success of Kir as a summer cooler has now extended far beyond the country of its birth.

French white Burgundy wine works the best for Kir, but Californian Chardonnay makes a good substitute. Place one teaspoon or tablespoon (according to taste) of "crème de cassis" in a chilled wine glass and add the wine. It is essential to use "crème de cassis" rather than "cassis." Only the concentrated "crème" has the body and depth to disperse the flavor throughout the wine. If in doubt as to the proportions of "crème de cassis" to wine, judge by the color of the finished mix. It should be somewhere between "blush" or rose, and a light red wine such as Beaujolais.

Kir is not only easy to make, but also lends itself to several variations. Add ice and an equal proportion of club soda for a more thirst-quenching beverage. Substitute dry vermouth for white wine to enjoy a more herb-flavored cooler. Use champagne instead of white wine and you have "Kir Royale."

Champagne also provides the wine base for numerous combinations to cool the fevered brow when the thermometer begins to rise. One of the best known is "Mimosa"—champagne and orange juice. This originated at Bucks Club, a favorite haunt of the London smart set at the turn of this continued on page 86

PHOTOGRAPHY: Jack Richmond / FOOD STYLIST: John Carafoli
PROPS: Jennifer Wilkin

FOOD VINEYARD SOUNDINGS

Jack and I have worked together on many projects. Another was the black-and-white photograph shown here, to illustrate a feature I wrote for *The Boston Globe* before they were using color in this section. The article was about one of my trips to Mexico and Mexican cuisine. I wanted to experiment with the illustration—I wanted a smashing visual, something dramatic. Shooting in black and white requires attention to contrast, especially for photographs reproduced in newspapers where definition can be a problem.

The paper gave me free reign and three-quarters of a page to fill. I had to decide what subject would best symbolize Mexico. The idea of showing a margarita, one of the recipes given in the article, seemed perfect.

To create beads of sweat on the margarita glass, I sprayed it with glycerin and water. Jack and I tipped it to add interest to the shapes, and I placed a round of lime on the glass's salted edge. A spritzer was hidden behind the hand holding the lime wedge. The spray from the spritzer was coordinated with the release of the camera's shutter.

In addition to Jack, it took three people to create this shot: one holding the glass, one holding the lime, and me spritzing. Jack's comment: "I backlit the shot so it looked like the spritz was coming out of the lime. Putting a spotlight on the spritz gave it a real glow and emphasized the contrast. In the first few takes we got the shot."

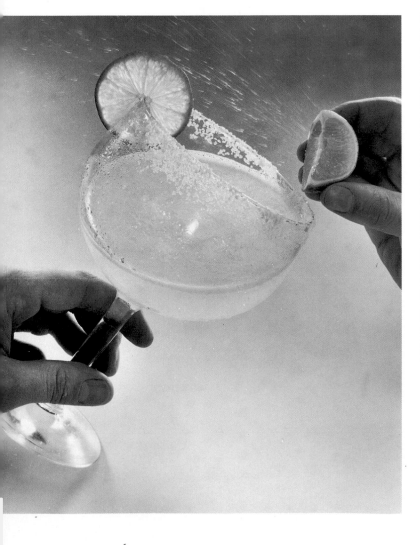

Drinks

Jack and I illustrated a menu of drinks for Ground Round Restaurants by styling and shooting each drink separately. We had to follow the Ground Round's "specs"—in this case, the real ingredients used in their drinks—so everything I used to style them was natural, except the ice cubes—they were acrylic.

The piña colada (below left) was an icy blend of Hawaiian pineapple juice, creme of coconut, crushed ice, and rum, garnished with a pineapple wedge and a cherry. Before filling the glass, I coated it with acrylic and spritzed it with glycerin and water to make it look chilled. I cut several pineapple wedges before I found a slice that showed the right texture, and I went through two large jars before finding the perfect maraschino cherry. (Flawless ones are practically nonexistent because they are all pitted. Positioning a cherry's good side toward the camera and generously coating it with glycerin helps to cover its imperfections.)

Spiced tomato juice with vodka, the Bloody Mary (second from left), was served in a tall glass with a wheel of lime and a crisp celery stalk, pulled from the interior of a celery bunch. (Finding a stalk with leaves on the outside of a bunch is difficult because produce workers in stores usually cut the leaves off—celery from farm stands is a better bet for celery leaves.) After preparing the glass, I arranged acrylic ice cubes inside and poured the drink. The lime wedge was backlit to make it and the celery leaf look somewhat translucent.

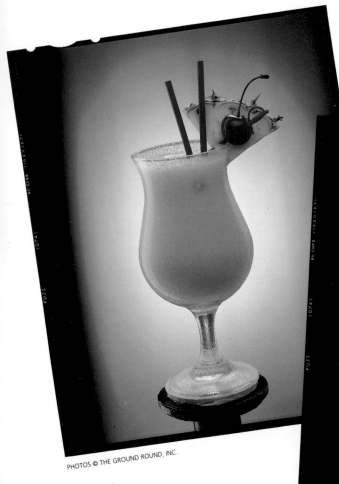

PHOTOS © THE GROUND ROUND, INC.

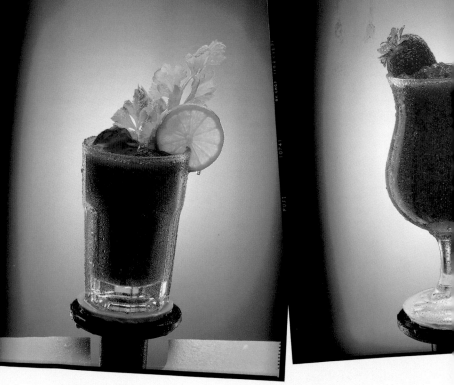

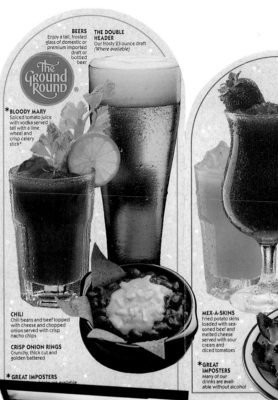

DRINKS AND APPETIZERS

STRAWBERRY COLADA *
Cool and creamy, made with strawberries and garnished with fruit

FUZZY NAVEL
Florida orange juice and peach schnapps

ORANGE 'N WHITE
Florida orange juice, triple sec, vodka and a dash of grenadine blended together with creamy soft-serve

PIÑA COLADA *
An icy blend of Hawaiian pineapple juice, creme of coconut and rum—Relax, you're in paradise

MOZZARELLA CHEESE STICKS
Melted cheese in a crisp breading served with marinara sauce

POTATO SKINS
Deep fried and crispy, topped with melted cheese, bacon bits, sour cream with chives

GREAT IMPOSTERS

BEERS
Enjoy a tall, frosted glass of domestic or premium imported draft or bottled beer

THE DOUBLE HEADER
Our frosty 23 ounce draft (Where available)

The GROUND ROUND ®

BLOODY MARY *
Spiced tomato juice with vodka served tall with a lime wheel and crisp celery stick *

CHILI
Chili beans and beef topped with cheese and chopped onion served with crisp nacho chips

CRISP ONION RINGS
Crunchy, thick cut and golden battered

GREAT IMPOSTERS

STRAWBERRY DAIQUIRI *
To keep the summer spirit going! Our frozen blend of strawberries, lemon-lime and rum

SCREWDRIVER
Florida orange juice and vodka

CHOCOLATE MINT KISS
One of our classics—creme de menthe and creme de cacao blended with fudge sauce and soft serve

WATERMELON COOLER
Melon liqueur and vodka blended with pineapple juice and a splash of grenadine

MEX-A-SKINS
Fried potato skins loaded with seasoned beef and melted cheese served with sour cream and diced tomatoes

GREAT IMPOSTERS
Many of our drinks are available without alcohol

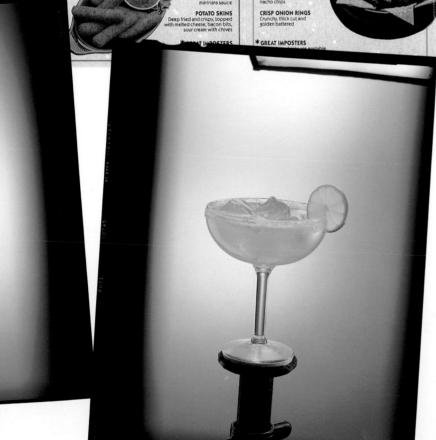

The daiquiri (third from left) was a frozen blend of strawberries, lemon-lime juice, and rum, and was garnished with a strawberry. I went through several boxes of fruit to find one with the perfect color, no blemishes, and a good green top. I spritzed it along with the glass to give the leaves a fresh look.

A blend of tequila, Triple Sec, and lemon-lime juice, the margarita (fourth from left) was handshaken, served on the rocks, and garnished with a wheel of lime. I didn't spritz the glass because I wanted the drink to have a cleaner appearance and bring a little variety to the menu. In keeping with client's specs, I salted the rim in a traditional, bartender's way by dipping it in lime juice and then into the salt. (Some stylists spray the rim with glue and dust it with salt.)

Jars and Cans

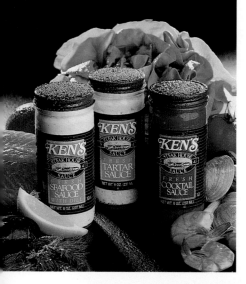

Peter Rice photographed Ken's Seafood Sauces for a promotional flyer for the client and for a coupon ad in local newspapers. The client wanted a garden-fresh look for their new sauces for fresh fish and shellfish. We decided to use salmon and shrimp to add color and put fresh produce in the background to carry the theme, garnishing the shot with dill and fresh lemon. The shoot was at Peter's studio in Boston. He backlit the set to make the lettuce translucent. I had bought hundreds of dollars worth of produce. As usual I bought far more than we used in the final photograph so I could pick the perfect head of lettuce to ensure the freshest look, and best color and shapes possible.

Spritzing the jars, I had to protect the labels since they were dummies created especially for this shot. First, I covered the jars and their covers with acrylic spray, let them dry, then misted them lightly to create the beading effect. With all the spritzing and spraying, the shot had to be taken right after the final beading.

My only problem was the art director's insistence on touching the food. I finally slapped her hand and explained how important it is that only the stylist adjust the food.

Peter also did a diffused shot of the setup, which the client didn't use because the product wasn't clearly enough defined. But both Peter and I use it as samples in our portfolios.

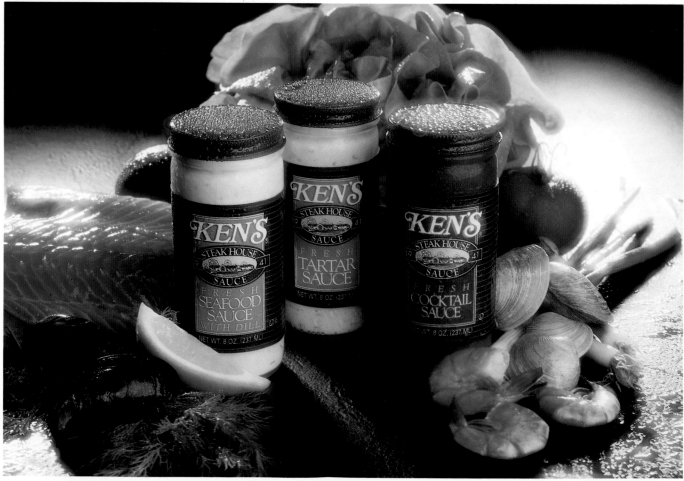

On another shoot, Paul Dube (of Hotshots Advertising Photography in Salem, Massachusetts) combined acrylic cubes and Crystal Ice to create a bed of crushed ice. Two spritzed cans of Sunbrew Iced Tea and Iced Coffee were set on the ice cubes, and the Crystal Ice was used as fill to mimic crushed ice. The set was lit from below for an "up light" surface on the artificial ice and to get rid of its gray cast.

The client, Ocean Spray Cranberries, superimposed the photograph against an airbrushed illustration to produce their final promotional piece. The straw in the illustration leads from the photograph of the cans into the mouth of the painted model.

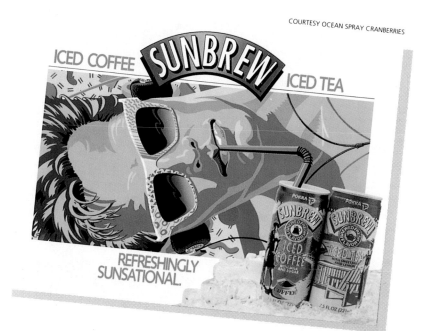

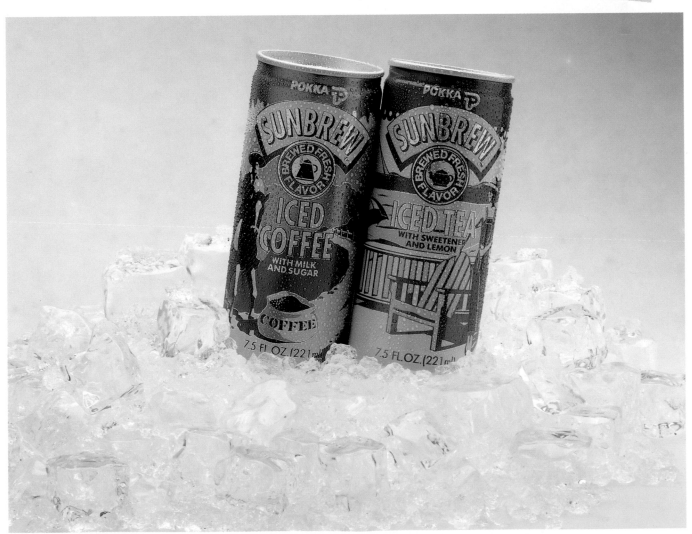

Spritzing and Spraying Step by Step

In this demonstration photographed by Jack Richmond, I arranged acrylic ice cubes so that some of them were pressed against the glass. The drink looks more interesting when the ice is designed this way because it refracts more light when the fluid is added.

Holding a folded paper towel as a mask across the top of the glass, I sprayed it with clear acrylic, being careful not to coat the glass above where the fluid would be, and

protecting the ice cubes as well—real ice never has beads of moisture on it. Next I sprayed the outside of the glass with a glycerin and water mixture. The coat of acrylic gave the beads of moisture a resistant base to cling to so that they didn't quickly roll down off the glass.

Again, holding a paper towel to protect the ice cubes, I used an aerosol paint sprayer to mist the glass lightly with a

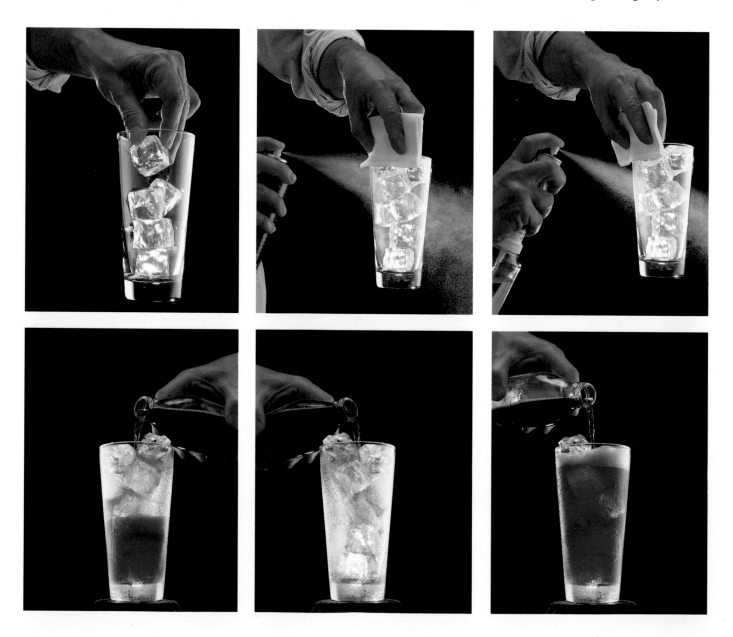

fifty-percent solution of glycerin and water. I continued spraying lightly to build up the amount and size of the beads, working with Jack until the desired drip and beading effect was attained.

I poured the soda into the glass, being careful not to pour too fast and create excess foam. Jack shot the final photograph quickly just as I pulled away, and we succeeded in showing the effervescence and small bubbles created by the fizz in the soda, which last for only a few seconds.

Timing is often critical. Spritzing should always be done just before the shutter goes off, which means the photographer has to be ready to shoot as soon as the stylist finishes preparing the drink.

Jack says, "I work very quickly. As soon as things are spritzed and the stylist has created natural, real bubbles, I shoot. Sometimes the stylist creates bubbles by adding Photo Flow or egg white with an eyedropper. If the drink dies, then we have to do a whole new pour with a clean glass."

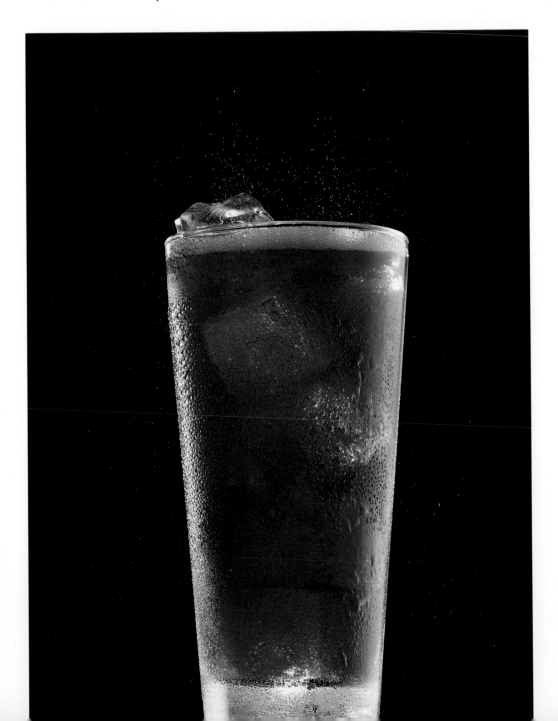

TECHNIQUES FOR SPRITZING, SPRAYING, AND ARTIFICIAL ICE

SPRITZING AND SPRAYING A GLASS

You'll need the following: water, glycerin, an acrylic or polyurethane clear spray, a regular or aerosol spritzer that can create a light mist, and two or three different sized syringes or a turkey baster (for removing excess liquid from glasses).

Use a clean new glass. Wash it with soap and water, and dry it with paper towels so no lint residue is left on the surface. Then clean it with glass cleaner. Make sure the cleaner you use doesn't leave a film on the glass.

Coat the outside of the glass lightly with acrylic spray such as clear polyurethane or clear acrylic (Krylon and Scotch Guard are two brands that work well). Do this several times, making sure the acrylic is dry before spraying the glass with the glycerin and water mixture.

In a spritzer (regular or aerosol) mix a fifty-percent solution of glycerin and cold water. Shake the solution and let it sit until the bubbles disappear, about five minutes.

Place the glass on your set, and arrange artificial ice cubes in the glass. Hold a paper towel over the cubes so the glycerin mixture doesn't hit them. Drops of water should never appear on the ice cubes—if they do, it is a sure sign that the ice isn't real.

Spray the glasses lightly with the glycerin mixture, and gradually build up beads on the glass. Get input on how they look from the photographer and the client. Some clients want more beading (or larger beads on the glass) than others.

With a lot of practice, you'll be able to control the drips on a glass so well that the photographer can shoot them just as the drip is halfway down the glass. This technique for spritzing and spraying can be used on anything that requires a cold, refreshing look.

MAKING ARTIFICIAL ICE

Crystal Ice

This water-absorbing polymer is supplied in granules. Water is added to it in varying amounts to produce a material that is gelatinous to the touch but appears crisp and cool. Using Crystal Ice is a good idea when large amounts of artificial crushed ice are needed. One tablespoon of Crystal Ice activated by two cups of water makes about two cups of "crushed ice." It can be made in a couple of hours or allowed to stand overnight. Be sure to drain off any excess water before using it on the set. I make Crystal Ice in the studio on the same day as the shoot. It is long lasting and not affected by studio lights.

Ice Powder

Another water-absorbing polymer, Ice Powder can be made to look like frozen slush or shaved ice, and it looks great in frozen drinks. It also can cling to bottles, cans, and food, and remain there, continuously adjustable, for hours. Supplied as a powder, this material plumps up instantly on contact with water. For a frosty look, dust the powder over a moistened surface. A fine-mist atomizer or spritzer can be used to add more moisture. You can also sprinkle Ice Powder onto a wet surface with a salt shaker or flick it on manually.

Poultry

Using just the right amount of "makeup" on the bird is the secret to giving poultry a truly home-cooked look.

WHAT IS A THANKSGIVING DINNER without candlelight, a feeling of warmth, and a beautiful, steaming turkey to commemorate the day? Styling poultry to enhance the comfort and security we associate with it is a wonderful assignment, as I discovered while setting up a double-page interior spread and cover shot for an issue of *Rhode Island Monthly*. ♂ Donna Chludzinski, the magazine's art director, and I decided that we wanted to create a turn-of-the-century feeling in the photograph. "Our audience enjoys seeing food on the cover," Donna said, "and the timing seemed appropriate. I envisioned a lush, old-fashioned floral arrangement with soft, subdued lighting from candles that had burned very low in brass candlesticks, evoking the richness of the Victorian era." ♂ Jack Richmond was our first choice to photograph the piece because we were both familiar with the way he choreographs a food set and were confident that he would help create an elegant, festive image. He agreed, and we scheduled the shoot at his Boston studio. ♂ My first job was to hunt down the turkey and the props. I looked for a fresh-killed bird that wasn't too large—we didn't want it to overshadow the other food—and carefully checked it for any defects in the skin (which I could camouflage if necessary). I found an antique shop that had just the right accoutrements: plates, serving dishes, candlesticks, and old tapestry fabrics. The shop was willing to loan these to us in exchange for a credit line in the magazine. Donna ordered roses for the table well in advance of the shoot to ensure that they would be full and open on that day. All the food was bought and much of it prepared ahead of time to keep the shoot as simple as possible. ♂

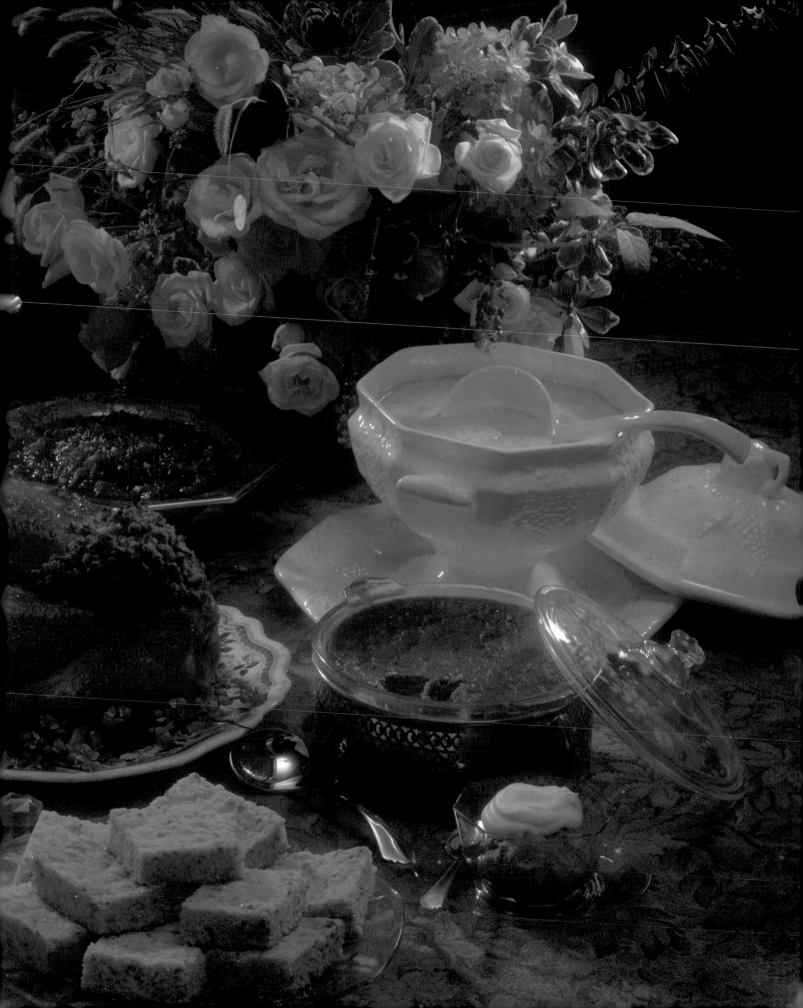

Poultry

The morning of the shoot, I arrived at Jack's studio with too many props, as usual. I always like to be sure that when we start putting things out on the table, we have a variety of choices. Our borrowed plates had a thin layer of dust along their edges that pleased Jack; he liked the subtlety and patina created by the dust.

I had baked several corn breads and Indian puddings, and now had to decide how to present them. The considerations were: Should we show a single serving of the corn bread? Or perhaps heap a plate with many portions? We agreed that a plateful looked best. As usual, I added water to the red wine so that it wouldn't photograph too dark. Otherwise, I'd prepped almost everything ahead of time. The Indian pudding, the relish, and the soup were done, so I was able to concentrate on preparing the turkey.

Because this was an editorial shot showing an entire bird, I was able to take some liberties with it. My main concern was with its color—I wanted the skin to be a rich, roasted golden brown. If we'd been photographing sliced turkey breast for an advertisement or TV commercial, I would've had to cook the bird thoroughly, which takes hours, or steam the exposed meat so that it wouldn't look raw, being very careful to preserve a nice skin. (When you're photographing poultry as a product for an advertising client, it is important to keep at least ten birds on hand for the shoot, in case problems occur.)

For this shot, I was really just putting "makeup" on the bird. The turkey went in and out of the oven five times. Each time, I sprayed it with a browning-agent mixture (see page 38) and put it back in the oven to bake until I was satisfied with the color. I oversaw the browning process carefully in order to prevent the turkey from getting too brown.

While I cooked an instant stuffing on top of the stove, Jack and his assistants set up the lights and the camera. Jack created ambient light for the photograph by throwing a banklight up onto the ceiling with a wide-angle reflector. A bright sidelight with a silver umbrella was set up next to the table. The ambient lighting from above filled in all the shadows cast by three direct heads: one on the right, one skimming across the top of the turkey, and one coming across the foreground of the photograph. According to Jack, "they were actually spotlights. I can scrim and use cards to direct a spotlight wherever I want it; that is what creates the glow."

To create a similar feeling for the cover shot and the inside photos, he warmed the color of the light by putting conversion filters on the heads of his strobe lights. As he explains, "This changed the light from 5,000 degrees Kelvin, the balance for daylight, to 3,200 degrees Kelvin, which is the balance for a standard lamp. Using daylight film with an indoor lamp results in a very yellow image because the lower the temperature, the warmer the light." This lighting scheme added to the warm, appetizing feeling we wanted in the photograph.

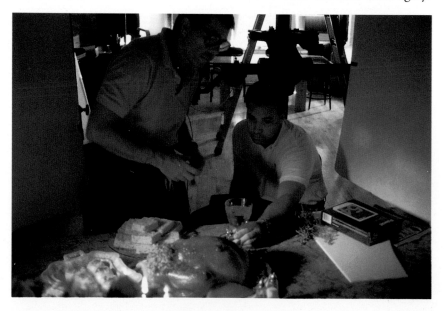

Jack (on the right) and me at work.

Jack shot the image in two exposures: one for the candlelight, and one for the strobe heads. He used an *f*/45 aperture with a shutter speed of 8 seconds, using the direct lights to create depth and put highlights on the turkey and other food, while keeping the background soft, diffused, and painterly.

Although everything was planned, nothing was "over thought," which left room for some spontaneity. But as Jack points out, "There are things to consider, like camera height (which we varied between the two shots) and how to create a visual flow across a spread of pages so that the reader will want to look at the whole image."

It was a joint effort all the way. We kept page design in mind and were concerned about leaving areas in the photographs for type, so we did preliminary layouts after we had everything set up, putting all of our props—the platters, dishes, and containers—into the picture frame first without bringing the food onto the set. Then Jack shot Polaroids that we enlarged on a copier to actual page size so that Donna could sketch in her type. We discovered that the candles were extending into the headline area on the cover, so we cut and burned them down to the right height. "You have to pay attention to every detail," says Jack. "Otherwise it will haunt you when you go to put the final image together."

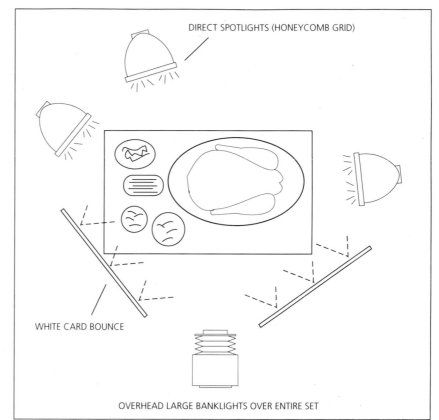

DIRECT SPOTLIGHTS (HONEYCOMB GRID)

WHITE CARD BOUNCE

OVERHEAD LARGE BANKLIGHTS OVER ENTIRE SET

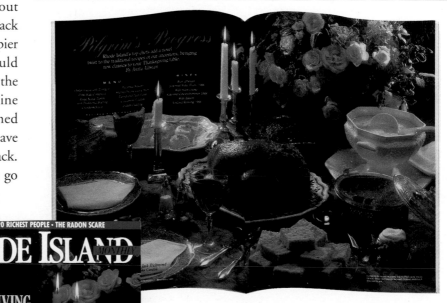

COURTESY *RHODE ISLAND MONTHLY*

Poultry Step by Step

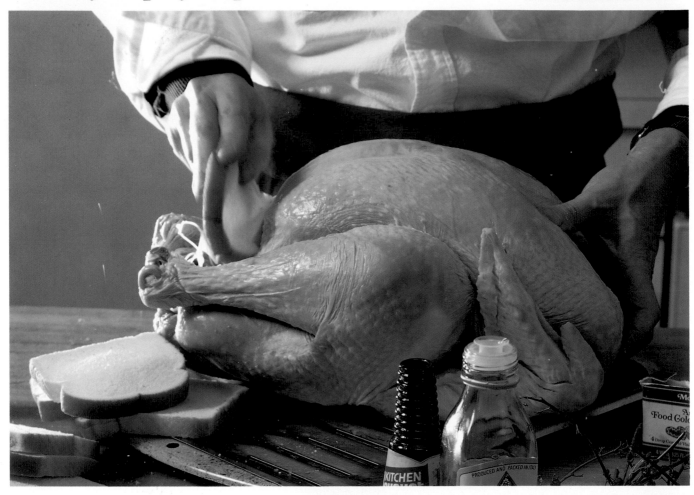

I stuffed the neck and large cavity of the bird with as much soft bread as I could pack inside to give the turkey a nice rounded shape (above). Usually, a fourteen-pound turkey takes a giant loaf of soft bread.

Then I pulled the skin of the turkey taut and pinned the neck with common pins so that it would stay smooth and not wrinkle while cooking (right). Usually, I tie the bird's legs together with dental floss that is then hidden by the stuffing. In this case, the turkey came equipped with a plastic binder, so using dental floss wasn't necessary. I turned and folded the wings under the body. (Wings can also be attached to the body with a strong adhesive or be pinned down, but care must be taken that the pins don't appear on camera.)

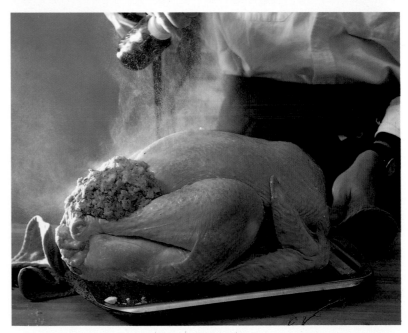

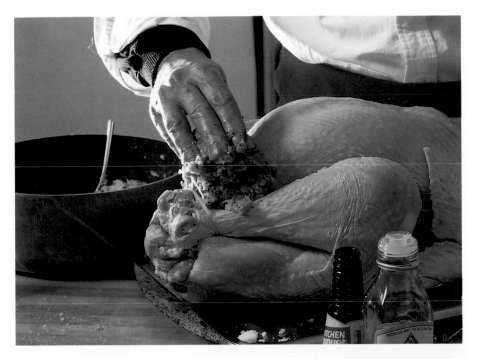

Instant stuffing, cooked on a stovetop, was added around the legs at the bird's large cavity to give it a true "roasted turkey" look (left). Try to find an instant stuffing with herbs for color, or add your own herbs.

Next I drizzled the bird and the broiler pan with oil, making sure both were well covered so that the bird wouldn't stick to the pan (below).

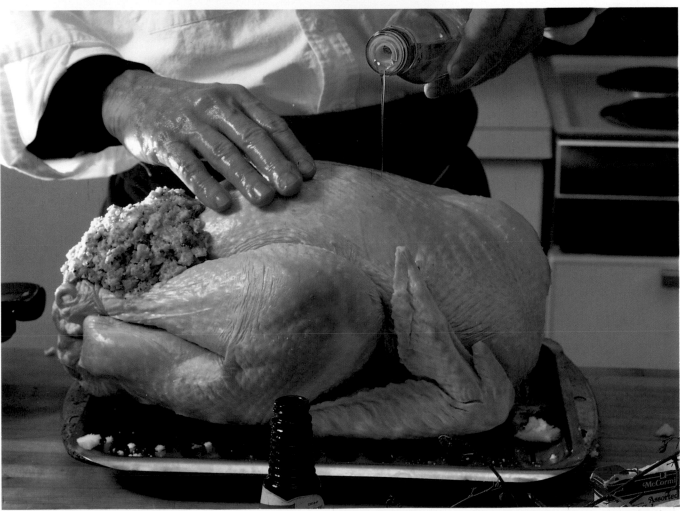

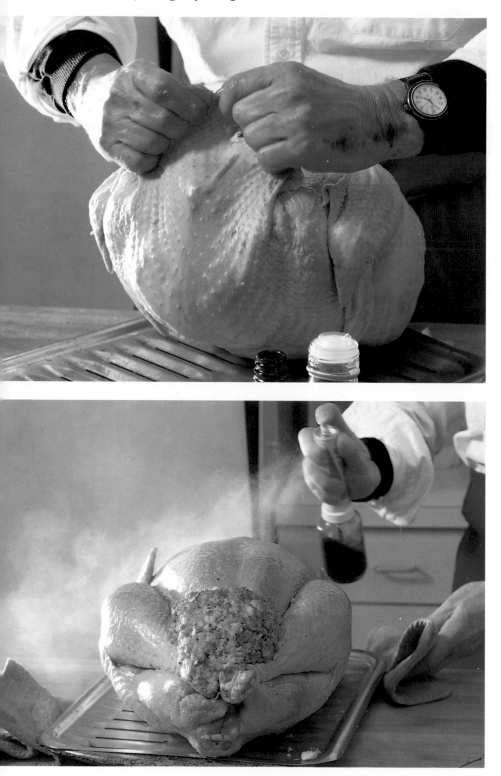

The browning process was done in a very hot oven, as I wasn't trying to cook the turkey, only to color it. I had set the oven at 450 degrees, and the turkey at this point (left) had been in for fifteen or twenty minutes. I knew the skin was hot by the sound of the oil sizzling in the pan. I sprayed the turkey with a coloring solution made from Kitchen Bouquet (a gravy coloring), food coloring, and a little liquid detergent (the soap helps adhere the water-based solution to the oily skin).

I put the turkey back in the oven for another five minutes. I kept opening the oven every five to seven minutes to make sure that the skin colored evenly and didn't burn. I continued this respraying (bottom left) and "cooking" until the desired color was obtained. Another technique food stylists use is painting the bird with a large pastry brush, using the same coloring mixture. I prefer to spray poultry because I feel a bird is best colored with a fine mist rather than by attempting to reach all the areas in between the wings and the legs with a brush.

I did, however, use a small paintbrush to touch up any uneven spots of color (right). At this point, I needed to correct any defect in the skin that I hadn't noticed before I initiated the browning process. My goal was to get an even coating of brown over the entire turkey.

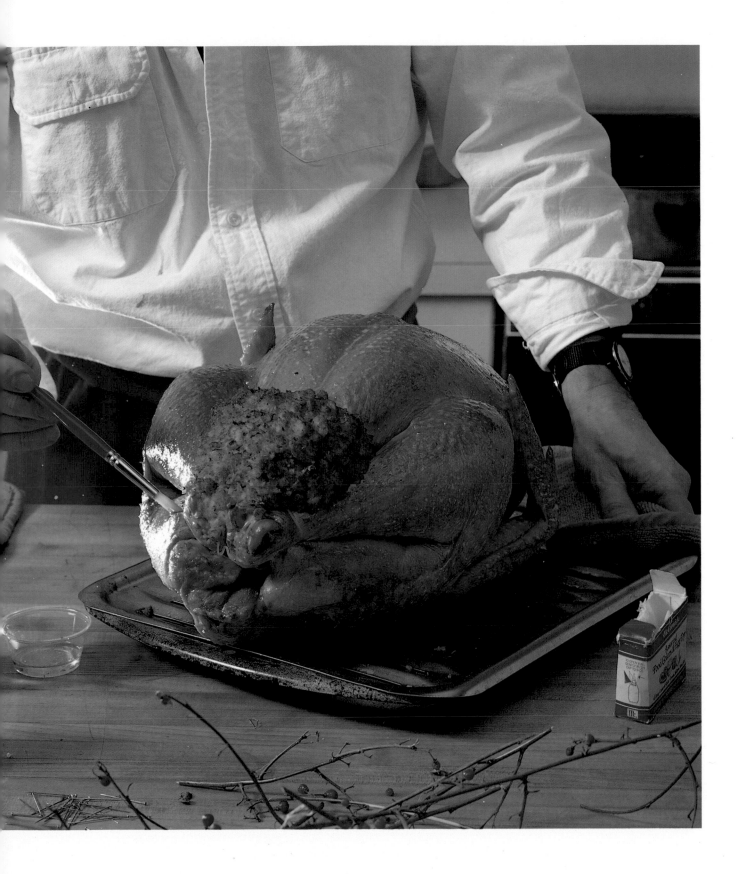

TECHNIQUES FOR PREPARING POULTRY

BUYING POULTRY

The following applies to buying turkey, chicken, duck, or any fowl: Always purchase fresh birds if possible. When buying frozen birds, look for ones without a plastic thermometer inserted because it will leave a hole in the skin when removed. Discuss the size and shape of the bird with the photographer and client to get an idea of what they want. Buy an appropriate-size bird for the scale of the photograph. Shapes and sizes of poultry vary. Look for birds that have a nice, plump, round shape.

Always buy several birds. I often buy three or four for an editorial shoot to ensure that one is the right size and without any grave defects when I open it up. The photographer can use one of the extras as a stand-in to set up the lighting. (I've often ended up using what was supposed to be just the stand-in for the shoot since it looked perfect, after all.)

PRE-PREP WORK

Always check the poultry for shape and defects before you arrive at the studio. If the poultry is frozen, let it thaw according to the directions on the package. Remove the neck, gizzard, and liver, and discard them. Wrap the bird in plastic or keep it in a plastic bag so that it doesn't dry out.

AT THE STUDIO

To test for color, shape, and size, select a stand-in bird that is close in shape and size to the one you intend to use as the "hero." Always discuss the stand-in with the art director and photographer so that you all agree on the bird's size and color and know what side will be facing the camera. Be very clear with them about what you intend to do.

BROWNING THE BIRD

It is best to work with cold poultry. I keep it refrigerated until I'm ready to prepare for the shoot. Poultry fat has a tendency to become soft as it warms up, which makes it harder to style the bird.

Pull the loose skin taut, and fasten it with pins under the back of the bird, making sure the pins don't show. Fold the bird's wings under the body or adhere them to the sides of the body with a strong adhesive.

Stuff the bird's neck cavity with soft bread, shaping it as you work. Then stuff the body cavity with enough bread to make the bird look solid. Be sure the legs are tightly fastened to the body, and put prepared stuffing in the open end of the cavity around the legs.

Generously cover the bird with olive oil, and place it on a well-oiled broiler rack. Put the turkey in a 450-degree preheated oven. When the skin starts to get hot (about fifteen to twenty minutes), remove the turkey from the oven or work with it directly on the oven shelf. Spray or paint it with the following coloring solution. Repeat this process every five minutes until you obtain the desired color (determine this with the photographer). It should take about twenty to twenty-five minutes.

RECIPE FOR COLORING SOLUTION

½ cup browning agent (such as Kitchen Bouquet)

¼ to ½ cup water

a few drops of red food coloring

½ teaspoon of liquid detergent

Combine the browning agent, water, and food coloring in a small bottle, and mix well. Then stir in the detergent carefully to prevent too many bubbles from forming in the mixture.

Steam

The piping-hot look of steam can be created several ways. I prefer working with natural steam, the kind that comes from warming food on top of the stove.

PHOTOGRAPHING STEAM is a bit tricky. It takes an experienced eye with respect to design and an impeccable sense of timing. Capturing such an ephemeral effect can be quite a challenge. All photographs of steam should be shot against a dark background so that its wisps are clearly visible. ☕ There are many artificial ways to produce steam. One popular method is to hide "steam chips" within the food itself. Activating them with an eyedropper of water makes the chemicals in the chips release small wisps of artificial steam. Hiding a steaming kettle behind the set is another strategy. And in some cases a clothing steamer, held over the food, or a heat immerser, quickly withdrawn from liquid before the strobe flash goes off, can provide the effect. Some photographers use cigarette smoke, but I don't find that visually effective because it is denser and has a blue cast that is too defined. ☕ Photographing natural steam works best. In the photograph of the "hero" lobster on the next page, pouring boiling water over the subject augmented the steam coming from the boiling pot. Jack Richmond shot the assignment for a printing company that wanted to do a poster showing a typical New England theme. I liked the image so much that I used it to illustrate one of my own promotion pieces. ☕ Jack and I came up with this concept of showing a whole clambake in a pot. We decided we wanted to do a straight-on shot from the front, which posed a logistical problem: how to shoot a cross section of the pot's contents as it was cooking. The solution lay in cutting a piece out of the pot with a hacksaw and positioning the camera at the same level as the bottom of the pot. ☕

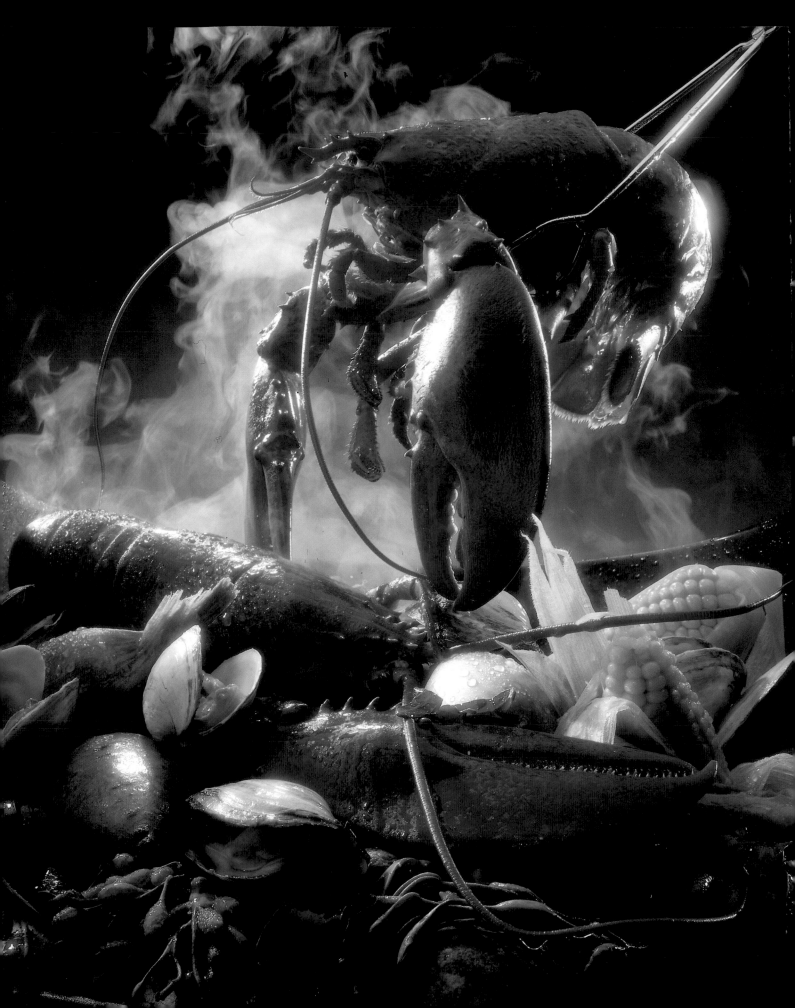

We left two inches of the pot's side beneath the cut-out section so that the pot could still hold water. I put a few rocks inside the bottom, added water, and put the pot on a small propane gas burner. By turning up the flame and boiling the water, natural steam was created inside the pot.

I blanched or cooked all the food for the photograph while Jack was preparing his lights, brought everything to the set, and designed it in the pot. I used clams, sweet potatoes, onions, a hot dog, and fresh native corn. Then I arranged seaweed, gathered from my own beachfront and blanched to bring out its acid-green color, in and around the ingredients. Next, we rigged an already steamed lobster to hang from kitchen tongs held over the pot.

Pouring boiling water over the hot lobster was the final touch, creating additional vapor for the shot. Earlier, we had turned on the air conditioner to cool the air in the studio, which increased the amount of steam rising off the hot food. This is a good technique to use when creating real steam.

We performed the pouring procedure several times until we knew we had the effect we wanted on film. Although pouring boiling water is always risky, no gloves or masks were necessary on this shoot. Jack used a #3 diffusion filter on his 4x5 view camera to make the highlights in the photograph glow; it also helped make the entire clambake appear fresh and appetizing.

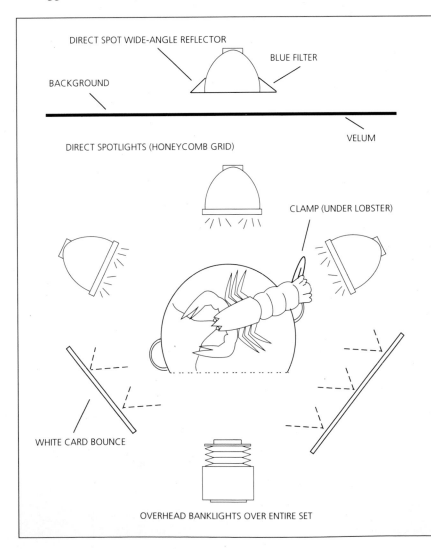

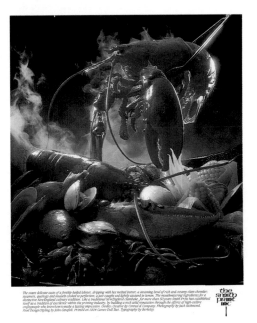

The sweet delicate taste of a freshly-boiled lobster, dripping with hot melted butter; a steaming bowl of rich and creamy clam chowder; steamers, quahogs and mussels cooked to perfection; a just-caught cod lightly sautéed in lemon. The mouthwatering ingredients for a distinctive New England culinary tradition. Like a traditional New England clambake, for more than 50 years Smith Print Inc has established itself as a tradition of excellence within the printing industry, by building a rock solid reputation through the efforts of high-calibre craftspeople who know how to make a lasting impression. Credits: Creative by Conrad & Company. Photography by Jack Richmond. Food Design/Styling by John Cangini. Printed on 100# Cameo Dull Text. Typography by Berkeley.

the
smith
print
inc

DIRECT SPOT WIDE-ANGLE REFLECTOR

BLUE FILTER

BACKGROUND

VELUM

DIRECT SPOTLIGHTS (HONEYCOMB GRID)

CLAMP (UNDER LOBSTER)

WHITE CARD BOUNCE

OVERHEAD BANKLIGHTS OVER ENTIRE SET

Steam

Preparing to give a seminar on food photography at the Photo Expo convention in New York City, Jack and I decided to experiment with unusual ways to illustrate steam. Here you see the results. First, I filled a heavy, black iron skillet with a bed of seaweed, then gently placed poached oysters topped with red salmon roe on the seaweed (top). Using tweezers, I carefully arranged the roe in each oyster (center). We put the skillet, holding an inch of water, directly on a small propane burner, which created the natural steam seen in the final shot (bottom).

Jack held the camera close to the pan and used backlighting to make the steam glow against the dark background. In addition to the backlight spot, he positioned a banklight on each side of the pan.

This successful demonstration of photographing natural steam for our seminar led me to try a similar setup for a client, Seatrade International (see page 44). Experimenting with new approaches to food is critical for food photographers and stylists; in this case, it gave me the confidence to know this technique would work when I was on assignment.

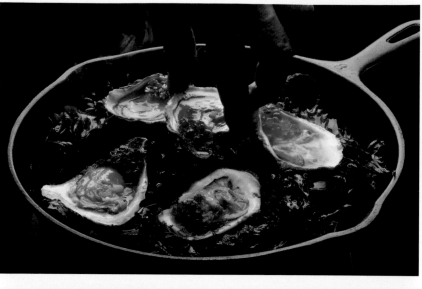

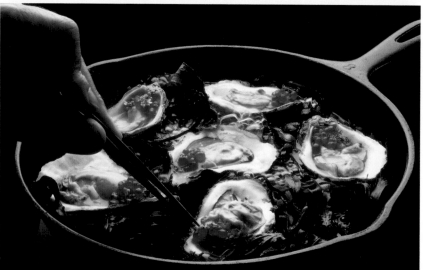

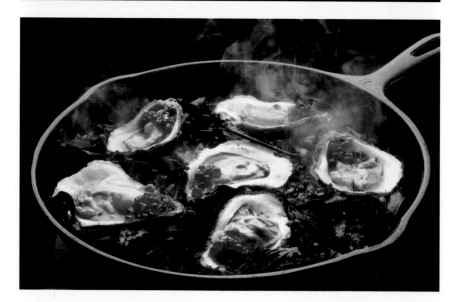

On another assignment for a Boston restaurant, Jack and I hid steam chips in a plateful of bouillabaisse, a fish stew containing lobsters, scallops, shrimp, and clams. The added wisps of "steam" were a delicate yet essential addition to this mouthwatering image of seafood.

Working with steam chips can be dangerous and demands extreme care. Don't overload the chips with too much water; follow the directions on the jar. On this shoot, I was brushing the lobster shell with a little oil when the chips ignited. Luckily, I moved just in time to avoid having my face burned by the flame that shot up like a flare. The plate holding the bouillabaisse broke, and the set caught fire. I turned to Jack and said, "I hope you got it!"

In this case, I had made the error of adding more steam chips and water to an existing container of chips. What I should have done was follow the directions more closely. You should know how a product works before using it.

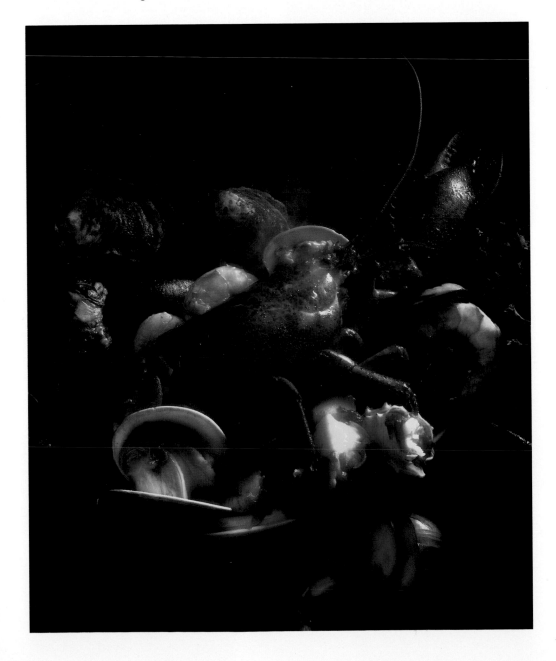

Steam

As you may have guessed, seafood is one of my specialties. I styled this photograph for inclusion in a brochure of recipes published by Seatrade International, a purveyor of fish. Seatrade provided us with recipes for shrimp and fish dishes. The photographer, Ned McCormick, and I had to design visually exciting ways to present them.

For this illustration, I decided to cook the fish in a pan and have Ned shoot the natural steam as the fish cooked. First, I precooked the fish in a separate pan, which gave me more control over its final color. The copper and stainless-steel pan seen in the photograph was positioned on a propane burner, and sea-urchin butter was melted inside it. I transferred the cooked fish into this pan, spooning a little of the sea-urchin butter over the fish. Then I added the other ingredients—sliced apples, and red and yellow peppers—arranging them randomly on top of and around the fish.

I continued cooking, and when the sauce and fish were hot enough, I dropped fresh basil into the pan in specific places for color. Ned shot the image straight down in order to show the texture of the fish, the natural steam rising from it, and the bubbles in the sauce.

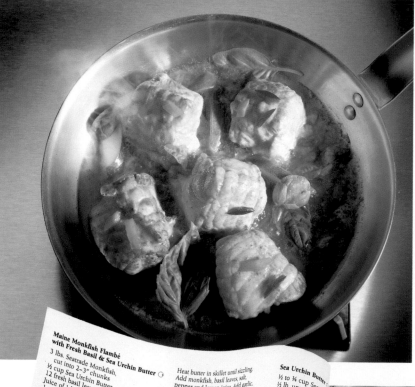

Maine Monkfish Flambé
with Fresh Basil & Sea Urchin Butter ○

3 lbs. Seatrade Monkfish,
 cut into 2–3″ chunks
½ cup Sea Urchin Butter
12 fresh basil leaves
Juice of 1 lemon
1 tablespoon crushed garlic
Salt & pepper to taste
¼ cup applejack brandy
2 peeled, cored, sliced apples

Heat butter in skillet until sizzling. Add monkfish, basil leaves, salt, pepper and lemon juice. Add garlic. Sauté over medium-high heat for 10–12 minutes.

Add sliced apples. Pour brandy (heated) over all and ignite. Serve directly from pan when flame dies down or prepare tableside.

Serve six to eight as entrée.
Preparation/cooking time: 15 minutes.

Sea Urchin Butter
½ to ¾ cup Seatrade
½ lb. unsalted butter
Juice of half a lemon
Dash of cayenne pepper

Whip all ingredients until ready to use.

Preparation time: 15 m.

IN THE REALM OF CAVIAR:
Seatrade Sea Urchins and Atlantic Pollock Roe virens) are much appreciated by gourmets. Our are just the right size—with the content, color preferred by Japanese buyers. Our roe is always our exclusive recipes by Chef James Haller are free on request.

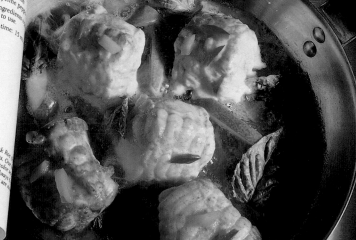

This photograph of a steaming souffle was shot as an illustration for a food article I wrote and produced for *The Boston Globe*, a newspaper that usually gave me free reign to do what I wanted in its black-and-white format. Looking for drama, I decided to use a black background with reversed type, a perfect foil for the steam rising from the souffle. I asked food shooter Frank Foster to take the shot. He kept the contrast high because the picture was for newspaper reproduction. We got the shot in one take, although I had already done a stand-in to test out techniques.

Creating the illusion of steam rising from the souffle was fairly simple. The skillet was placed on a black, velvet- covered table. Between the back of the table and a black backdrop, I positioned a steaming kettle on an electric burner and concealed them from the camera. After cooking the souffle, I returned it to the table and opened it up with two spoons. The white steam from the hidden kettle stood out against the black backdrop and created the illusion of a freshly baked, steaming souffle.

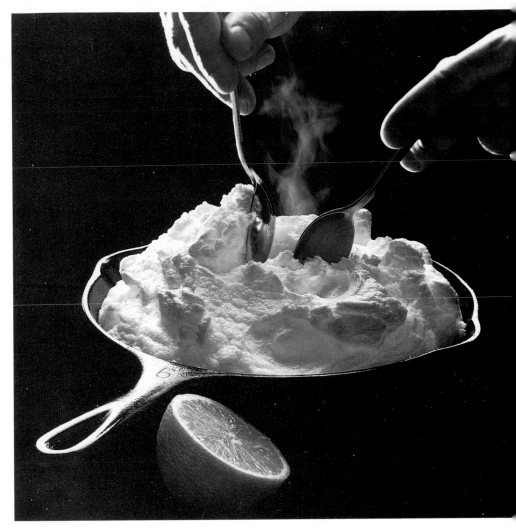

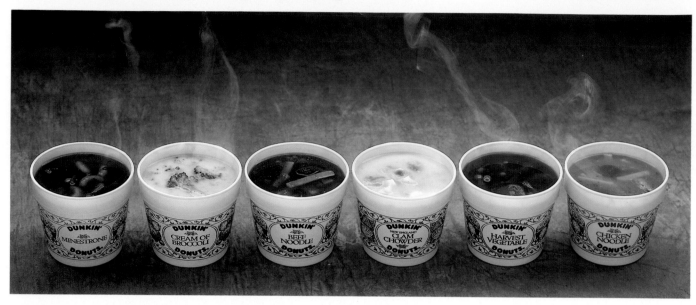

Jack Richmond and I shot a cluster of six soups for Dunkin' Donuts, which used the photograph to illustrate an in-store display piece. The art director wanted the soups to have a steamy, appetizing look. Because soup has a tendency to produce a surface film as it cools, six cups of soup had to be kept warm simultaneously, which was no small feat (I did it on a stovetop).

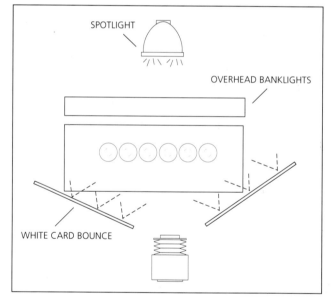

SPOTLIGHT

OVERHEAD BANKLIGHTS

WHITE CARD BOUNCE

Although the soup was kept hot, it wasn't hot enough to produce enough natural steam. To add steam, I decided to use a clothing steamer, a professional appliance for removing wrinkles from clothing by applying steam to them (see page 48). But first, I used tweezers to bring a few ingredients in each cup to the surface to create a better design and show off the product. I held the steamer over each cup of soup and forced steam into it, trapping visible steam in the lip of the cup above the soup. Using a steamer was a good solution. The steam stayed in place in the cup for several seconds, long enough for Jack to get the shot.

Jack rigged up a backdrop for the set. He put a strip banklight overhead and focused spotlights directly down on the cups to capture the steam. Then he shot at an angle to reveal all the ingredients in the soup (clients love to see everything in their products revealed on film). Jack said, "We had to arrange the spotlights so that they wouldn't hit the cups, only the steam. Next time I would use two clothing steamers. We had to redo the shot several times because some cups had more steam than others, and keeping them all even and looking the same temperature wasn't easy with just one steamer."

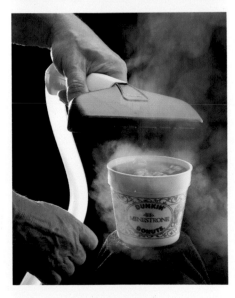

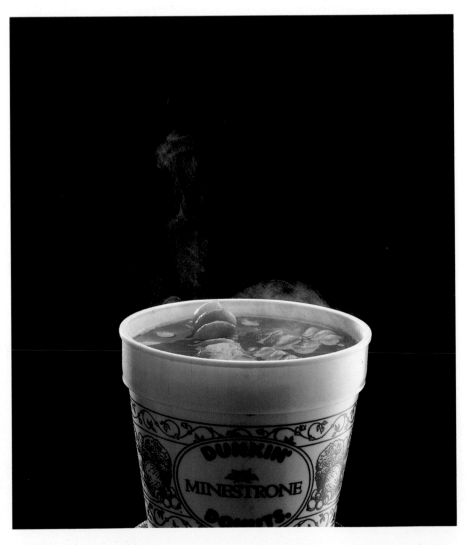

TECHNIQUES FOR STYLING STEAM

COLOR AND TEMPERATURE

Steam is white and needs a dark or black background to show up on film (styling steam for television or live action is an exception to this rule). If you are shooting food directly in a pan, you can heat the food on a small propane-gas burner.

When working with natural steam, the studio should be as cold as possible; the greater the contrast in temperature between the cold air and hot food, the more natural steam will be created. The photographer must be prepared to shoot when just the right amount of steam is present.

STEAM CHIPS

Before using steam chips, read all the directions and warnings on the label. Intended for professional use, they are spontaneously combustible and must be handled with great care. Their dust may be harmful if inhaled, and they must be kept away from sparks and open flame.

Use ¼ to ½ teaspoon in a metal bottle cap or in heavy aluminum foil. Then cover and reseal the jar tightly. A pinch of fine table salt, dissolved in the water that activates the chips, will increase their activity. They should be used only in Pyrex, ceramic, or heavy metal containers. Anything else might ignite, crack, or melt. Bottle caps work well.

Never use them where heat builds up, and *never add fresh steam chips on top of an expired residue of old chips.* Heat from the residue can make the new chips ignite. Also, never use them in a completely sealed container; an explosion could result. Have adequate ventilation, and wear gloves.

In Hot Coffee

Put a small container of steam chips behind the cup, out of the camera's view (you can make a small holder from heavy foil and attach it behind the cup). Add water to the chips with an eyedropper. When the steam is activated, gently fan it over the cup. You may have to try this several times.

In Baked Potatoes

Press a sewing thimble of steam chips into the opened potato and "dress" the thimble to hide it from view. Dispense a small amount of water with an eyedropper to activate the chips just before shooting.

CLOTHING STEAMERS

Clothing steamers are excellent for creating and adding larger amounts of steam. The steaming head can be concealed within the food or behind the set. The steamer on page 47 is a Jiffy steamer for professional and home removal of wrinkles from clothing. It comes equipped with a long hose, a steam head, and a removable rod for holding the hose. It is lightweight, easy to handle, and holds a gallon of water.

HEAT IMMERSERS

To heat a single cup of coffee or soup, you can use a heat immerser, available at most hardware stores. Place it in your hot liquid, bring the liquid to boil, withdraw the heating element immediately, and shoot. Whatever techniques for adding steam you use (and these are just a few), be prepared to do a little experimenting; it will probably take several tries before you get the perfect wisp of steam.

Pizza

A pizza must look hot and have recognizable, fresh ingredients. A golden crust makes it even more appetizing.

CAN ANYTHING TOP THE APPEAL of pizza right out of the oven? The answer is yes: a colorful and enticing topping. Essentially, a pizza is a crust made from flour, yeast, oil, and a pinch of salt. Covered with a medley of the freshest produce and cheese, dotted with spicy meats like pepperoni or with anchovies, a pizza is a labor of love. The possibilities for creating beautiful toppings for these Italian "pies" are endless—a stylist can go wild! The ancient Romans were among the first to eat pizza, but without tomatoes, which were unknown to them. The version we enjoy today is a direct descendant of a Roman breakfast dish, "bread with relish." When properly made, pizza is a well-balanced food, and, like pasta, it isn't fattening if eaten in moderation. Since World War II, many varieties of pizza have appeared in the United States, and our national lust for pizza has made it one of our favorite fast foods. Oval, square, minisized, and topped with such exotica as fruit or even shellfish, the subject of pizza is a photogenic delight for stylists and photographers. Fast-food pizza chains continue to pop up nationwide, giving food stylists more flexibility to create new images for advertising and visually "spice up" the finished product. Photographer Ned McCormick and I have worked on several pizza assignments together for different clients, all with high standards for the images they desired. One of them, Pizzeria Regina, wanted to create three 4×11-foot Duratrans of their pizzas and calzones for the walls of each of their Boston-area restaurants. (A Duratrans is a backlit display of a colored image on a paper emulsion, mounted on a white translucent or clear film base.) Our preproduction meeting with Pizzeria Regina defined their needs as a client and established our shooting plan.

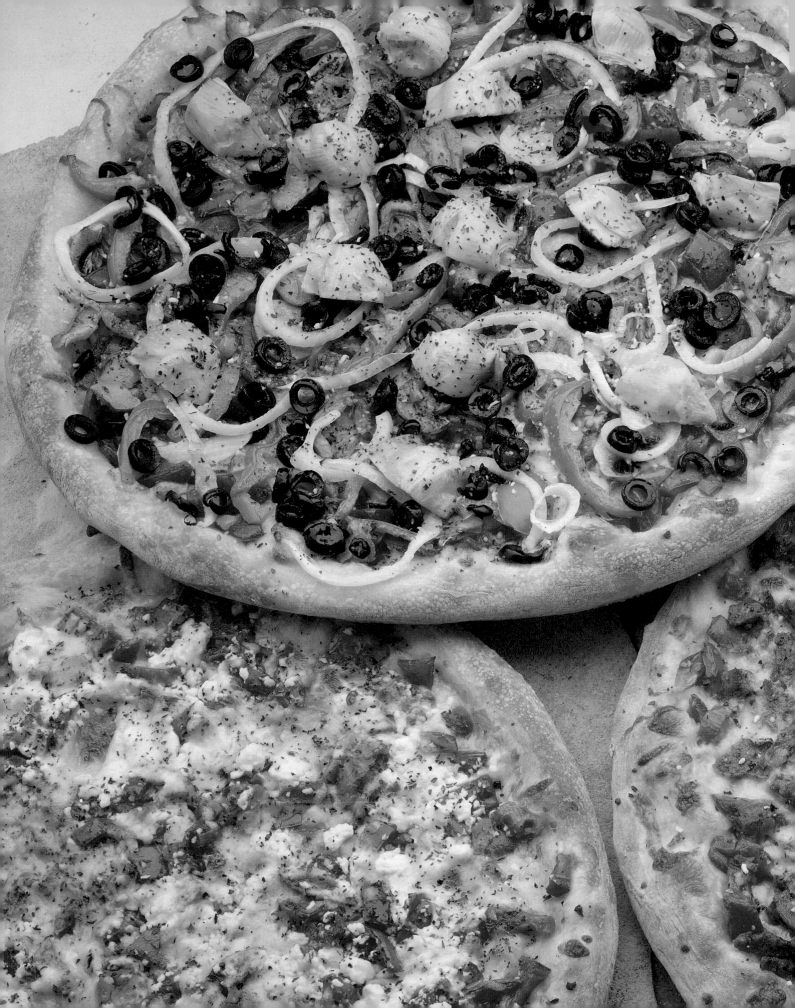

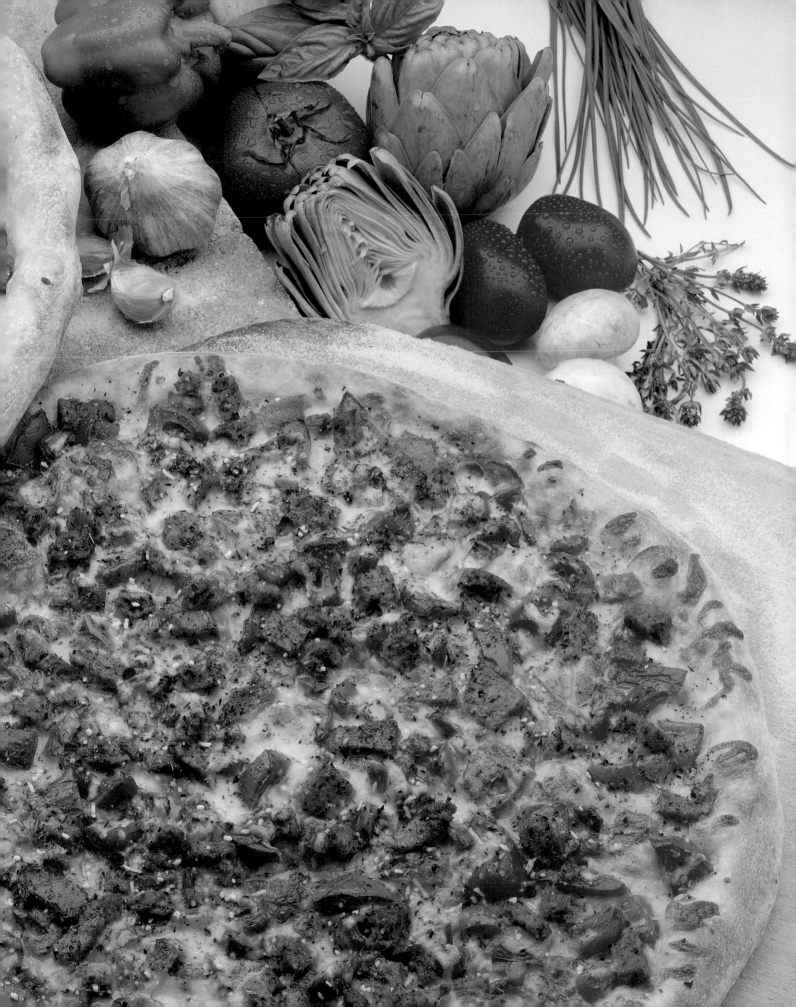

Pizza

NED McCORMICK

In the early seventies, Ned McCormick majored in photography at the New School in New York City. He completed his education in Boston at the New England School of Photography. Well known as a generalist in the Boston area, Ned became interested in shooting food in the late eighties. Today his clients include Burger King, Prince Spaghetti, Pizzeria Regina, and Cains' Mayonnaise.

Pizzeria Regina wanted shots of three dishes: two whole-wheat pizzas (below), a selection of meat- and vegetable-stuffed calzones (opposite page), and three gourmet pizzas with such toppings as scrambled eggs, feta cheese, and artichokes (overleaf). The client had initially planned to have everything shot in one frame and then cut the image into various sections for the duratrans. Ned and I explained that this wasn't a good idea because it would be visually confusing. We assured the client that three separate shots would make a stronger statement. That settled, we scheduled a Saturday shooting date when Pizzeria Regina's industrial kitchen with brick ovens could be available for the shoot.

I gathered the designated props: branches of dried wheat, a wooden scoop filled with wheat flour, and grains of semolina to accompany the vegetable accessories. All the produce and cheese had to be perfectly fresh as the duratrans were meant to be blown up larger than life—any staleness or other flaws in the food would show. Because one of the client's goals was to highlight the thickness of their pizza, we kept props to a minimum; we didn't want to distract from the subject.

Surrounded by the deep brick ovens at their kitchen, I worked with Pizzeria Regina's director of operations, who also created all their recipes: Anthony Buccieri, the *pizzaiolo*, or pizza chef. Designing the

image of the whole-wheat pizza, we focused on conveying four things: first, that the crust was whole wheat; second, that the pizza was thick; third, that it was baked in a brick oven; and last, that whole-wheat pizza is healthy.

Sometimes you're limited to using only the client's products in the photographs you're doing for them. That was the case here, but Pizzeria Regina happens to make a good dough and uses fresh ingredients, which made my job a lot easier. I always bring my own fresh produce.

Before preparing the pizzas (see pages 54–57), we let the ovens heat for several hours. Since brick ovens hold heat better and more uniformly than regular ovens, pizzas cook faster and more evenly in them, and the resulting crusts are golden and flaky.

Knowing that Pizzeria Regina didn't want the mood in their restaurants to be too dramatic, Ned lit the three sets openly with a large softbox but didn't fill in the shadows with too many bounce cards. That left some nice shadowing around the food. On the pizza shots, adding backlight with a white card highlighted the crusts' texture (see diagram). Ned used a warming filter to make the food look more appealing, which compensated for the loss of color saturation that occurred when the images were blown up into Duratrans.

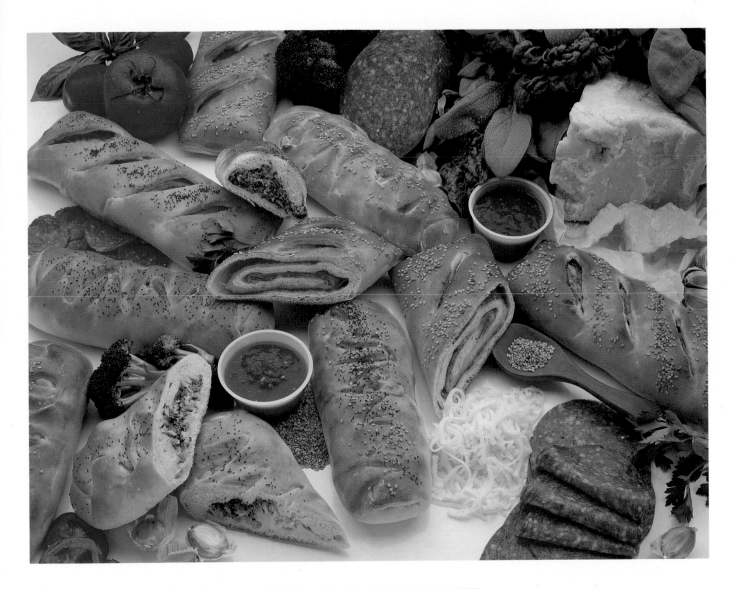

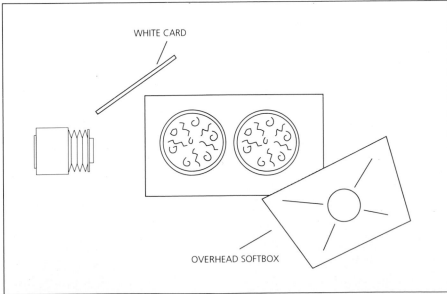

WHITE CARD

OVERHEAD SOFTBOX

Preparing Pizza Step by Step

I made the pizza dough in advance to allow plenty of time for it to rise. This recipe makes enough dough for one 11×17-inch rectangular pizza or two 12-inch round pizzas:

1 tablespoon active dry yeast

Pinch of sugar

1 cup lukewarm water
(105 to 115 degrees)

2 tablespoons olive oil

3 cups all-purpose flour
(or 2 cups whole-wheat flour)

1 tablespoon sugar

1 teaspoon salt

Cornmeal

1. Pour the water into a small, warm bowl. Sprinkle the yeast and pinch of sugar over the water until the yeast bubbles up, about 5 minutes. (If the yeast doesn't bubble, start over with fresh yeast.)

2. In the bowl of a food processor fitted with a steel blade, combine 2 cups flour, 1 tablespoon sugar, and the salt. Cover the processor, and turn it on and off a few times. Then, with the machine running, add the yeast mixture, olive oil, and remaining flour a little at a time, as needed, until the dough forms a ball. Stop the machine, and check the dough. If it feels sticky, add more flour. Turn the machine on again until the dough is smooth but not sticky to the touch.

3. Place the dough in a large bowl that has been lightly oiled, turning the dough until its entire surface is oiled. Cover the bowl with a damp towel, and put it in a warm, draft-free place (about 80 degrees) until the dough doubles in bulk, 1 to 2 hours. (A gas oven with a pilot light or a warm electric oven works well.) To test the dough, gently press your fingers into it; if they leave an impression, the dough is ready.

4. Punch down the dough with your fist. Transfer it from the bowl to a lightly floured surface. Starting in the center, roll out and stretch the dough to the desired shape, turning it over from time to time as you roll it.

5. Cover the bottom of a pan with cornmeal, and put the dough into the pan, stretching it to fit. Make a rim around the pizza by turning the edges under; this will prevent the topping from overflowing.

6. Preheat the oven to 450 degrees. Cover the pizza with a damp towel, and put it in a warm place to rise a second time, which takes 10 to 15 minutes. (The dough will continue to rise as it bakes.)

7. Garnish the pizza with the topping, arranging and designing the cheeses and sauces. Bake it, uncovered at 450 degrees for 20 to 30 minutes, or until the topping is bubbling and the edges are a golden brown. If the edge starts to brown too quickly, cover the edge with foil. Photograph the pizza while it is hot.

For one of the shots, we cut a wedge in the raw pizza dough so that we could show a "pull," or a slice being lifted from the pizza. Defining the pull in advance makes it much easier to separate the wedge from the pizza with a spatula.

I arranged strips of cheese perpendicular to the cuts in the dough so that the resulting pull would drip with a thick waterfall of cheese when it was lifted from the baked pie.

We spread the sauce and cheese over both pizza shells, added circles of green

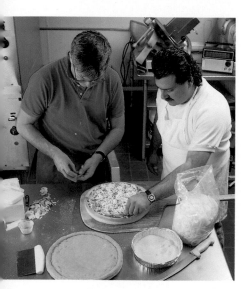

Styling the whole-wheat pizzas for Pizzeria Regina was a collaborative effort between the client's *pizzaiolo*, Anthony Buccieri (on the right), and me.

pepper to one, and put both shells into the brick oven until the cheese was evenly melted. We removed the pizzas with an oven carrier, also called a "pizza peel." Professionals use these large wooden paddles to transfer baked goods to and from ovens.

To one pie, we added sliced pepperoni after it came out of the oven, because pepperoni tends to buckle and curl under heat. For the other pizza, we handpicked the mushrooms and gently sautéed them before putting them on the baked pie. Raw mushrooms look just that: raw. They can become a tad dark in the oven, so it is best to sauté them separately and leave them in the pan's oil to retain a fresh-cooked look. Then they can be arranged on the pizza with tweezers at the last minute. (I usually brush them with oil just before the flash goes off.)

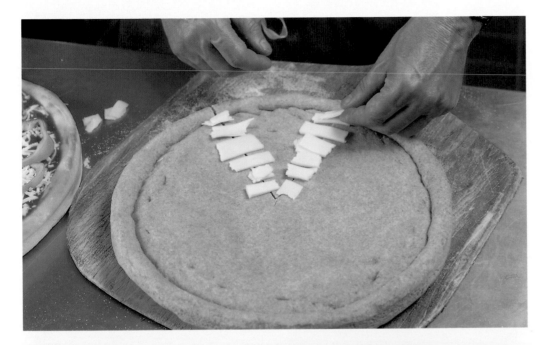

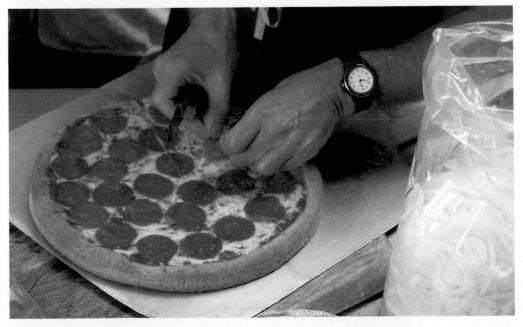

Preparing Pizza
Step by Step

The pepperoni pizza with the wedge cut for the pull came out of the oven last. I slipped the spatula under the wedge and let it sit there for a few minutes before making the pull. The secret to a good pull is not to do it immediately after the pizza leaves the oven—let the pizza cool slightly. Otherwise, the cheese has a tendency to be too thin and run off of the spatula.

After pulling the slice a few inches above the pie, I put two small cups under the spatula to support it (right). In the final image, the handle was cropped so that the slice doesn't seem to be hanging in the air. A few last-minute touchups with olive oil applied with a paintbrush (below) put a little sheen on the pepperoni for the camera.

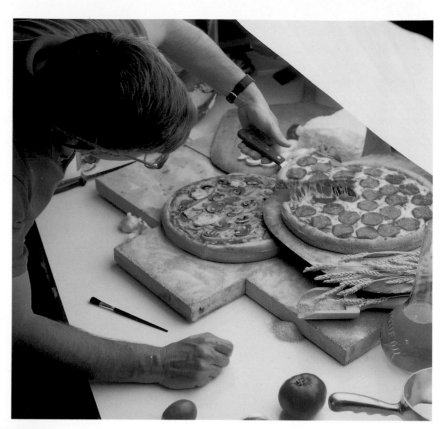

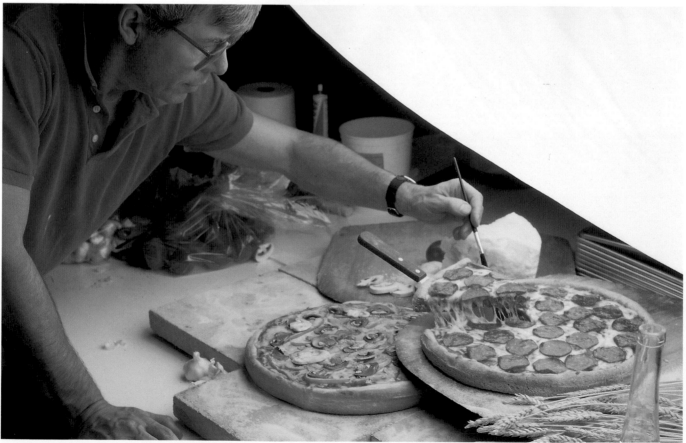

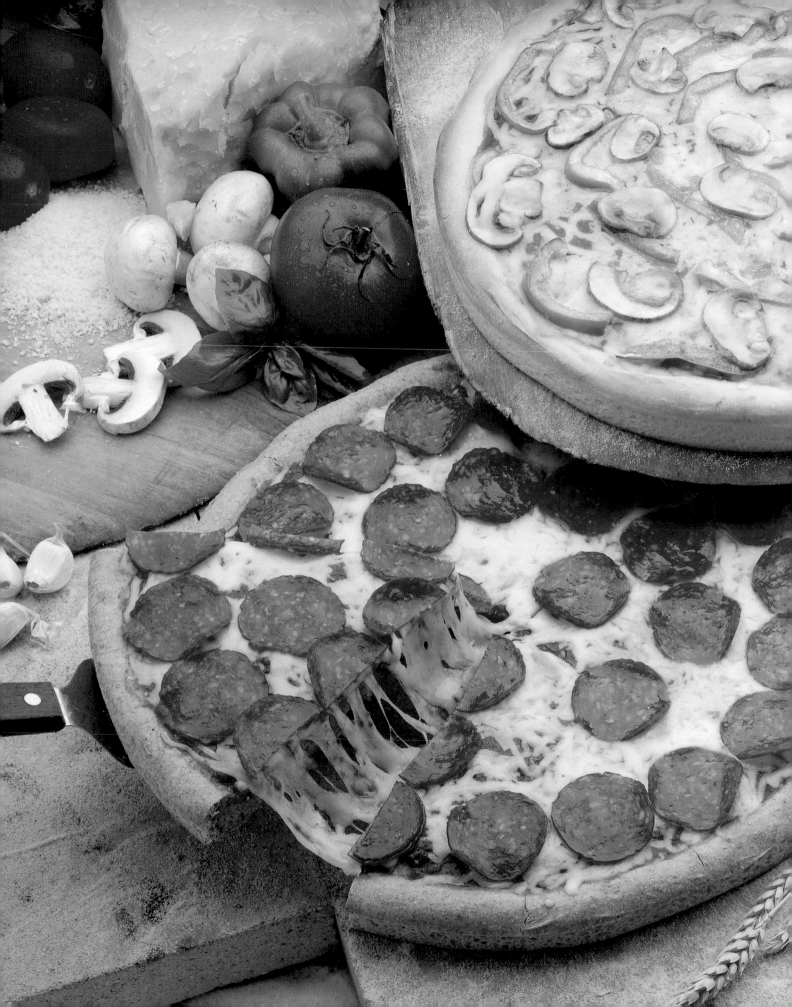

TECHNIQUES FOR STYLING PIZZA

PREP WORK

Make the pizza dough ahead of time (see the recipe on page 54), and keep it fresh in plastic wrap. (Yeast crusts are easiest to work with because they are elastic and hold together well; however, crusts can be made from ready-made biscuit, pie, and muffin dough, depending on the client's needs.) Yeast dough can be refrigerated overnight but should be allowed to rise the next day before you roll it out.

Make sure the photographer or client has an oven large enough to bake the pizza or pizzas. Always create a stand-in pizza first so the photographer can adjust the lighting on the set, so the client can see the toppings and make sure they follow their specifications, and so you can work out all technical problems. Bring your own fresh ingredients—peppers, mushrooms, cheeses, anchovies, plum tomatoes, pepperoni—whatever the client needs.

AT THE STUDIO

Prepare the toppings for the pizza. Cut nice shapes from the vegetables. If using mushrooms, sauté them lightly in olive oil, then put them on the pizza. Such vegetables as onions should be cut, sautéed until slightly brown around the edges, and then drained on paper towels. Sautéeing will remove excess liquid from the toppings.

If you are cutting a wedge in the dough to photograph a pull, cut the point ½ to ¾ inches beyond the center of pizza. This optical illusion will provide a nice wedge.

Use a thick, prepared, reduced-tomato, pizza sauce, and paint it in around the ingredients wherever it is needed on the shell. A paintbrush gives you more control in designing the pizza.

Put pepperoni on the pizza after it has come out of the oven. There is enough heat in baked pizza to melt the fat in the pepperoni and give it a nice sheen. Pepperoni that goes onto the pizza before it is baked shrinks in the oven and looks unappetizing.

Just before shooting the pizza, touch up the cheese and topping with a little olive oil using a paintbrush. You can use a heating coil, such as a paint stripper, to heat the cheese and topping. Always try to shoot the pizza while it is hot to prevent the sauce from developing a dull film as it cools. If this happens, touch the sauce up with a paintbrush and more fresh sauce.

HOW TO CREATE A CHEESE PULL

Roll out the pizza dough to the desired diameter. Allow the dough to rise (about 15 to 20 minutes). With a sharp knife, cut a wedge in the dough, but don't remove it—leave it intact. Next, place strips of cheese across the cut. Cover the wedge and pie lightly with sauce, then additional cheese, and bake the pie.

With the set ready, remove the pizza from the oven and place it on the set. Position the spatula under the cut, and allow the cheese to cool slightly. Next, make the pull by lifting the spatula up and slightly away from the center of the pizza. Position a support, such as a block of wood or anything not visible to the camera, under the spatula. Shoot immediately.

Ice Cream

Time on the set is limited by ice cream's fragile life span. A touch of melting ice cream is a convincing detail.

CAPTURING ICE CREAM ON FILM takes a good food stylist and a sharp photographer who is willing to shoot fast. Sometimes the best image is a mystery until the film is edited. Boston photographer Carol Kaplan says, "From my point of view, the difference between shooting ice cream and any other still life is minimal. Good photography lies in preparation; with ice cream we just have to work more quickly." ♀ As usual, the photographer and stylist work out the logistics of an ice-cream shoot in advance, and set up the shoot accordingly. The film and lighting are tested, and then they are ready to work with a "stand-in" of artificial ice cream (it doesn't melt) for the final Polaroids. In photographs that advertise a food client's product, only their product can be shown in the final image; in these cases, artificial ice cream is allowed on the set only as a stand-in. This is the law and has to do with truth in advertising. For editorial assignments or when featuring a sauce and not the ice cream itself, then artificial ice cream may be used. ♀ Artificial ice cream doesn't melt, but it will dry out. At times I've used a combination of artificial and real ice cream to create a more authentic look. Nowadays lights in the studio aren't hot enough to melt the ice cream immediately, but temperature control is very important. ♀ Always get the ice cream to the studio the day before the shoot, and keep it in a freezer set at 0-10 degrees. If the ice cream is too soft, it will be difficult to style. Ice cream with a high butterfat content renders the best texture. ♀

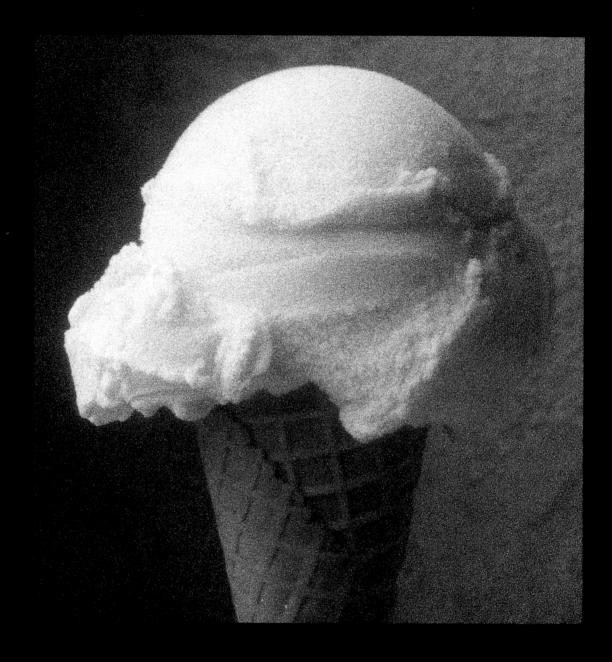

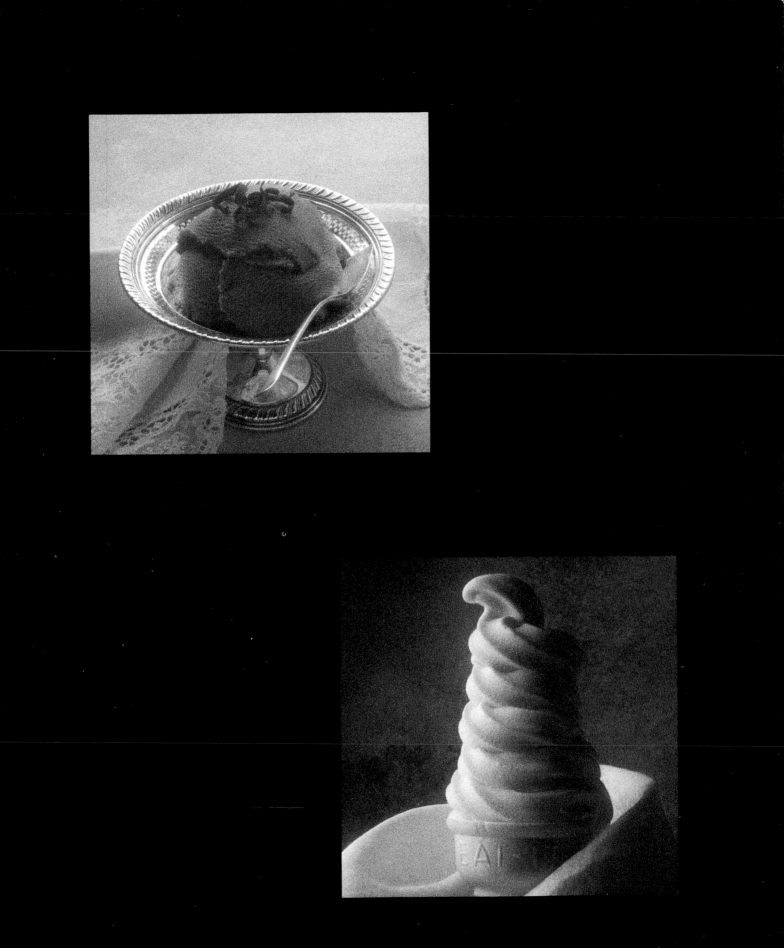

Ice Cream

CAROL KAPLAN

Carol Kaplan is well known for her people shots, especially those involving children. Her "amber glow" photographs of people and still lifes have brought her numerous advertising awards, including Andys and Clios, and awards from One Show, Hatch, and the Boston Art Directors' Club.

My philosophy about shooting ice cream is to "just scoop it and shoot it," but some stylists use the dry-ice method: scooping several perfect balls and putting them on a tray in a box of dry ice. The problem with this is that the dry ice creates crystals that must be blown off the ice cream with a straw. Still, some stylists really like this method and have the technique down pat. Dry ice must be handled carefully, using gloves. Zeroll ice-cream scoops contain a freezing agent inside the handle. Always keep scoops in bowls filled with pulverized dry ice or in a freezer.

Carol and I shot an ice-cream assignment to illustrate a brochure for HealthAssurance, a health-care organization. Because the ice cream's role was strictly ornamental, we were free to use either artificial or real ice cream as the client wasn't selling ice cream.

The shoot took three days, plus a day of preparation that included ordering several gallons of real ice cream and renting a soft-serve ice-cream machine. The first day of the shoot, we photographed the vanilla cone for the cover, using real ice cream. For the soft-serve shot, I gave a stand-in to Carol to use for adjusting the lights. I made it from a mixture of vegetable shortening and powdered sugar, pushed through a pastry bag to create ridges similar to those formed by the machine's dispenser. When it was time to shoot the real thing, Beth Werther (the art director from the A. Richard Johnson agency), Carol, and I had to agree how a perfect swirl of soft-serve ice cream looked. Carol shot it immediately.

In addition, we featured real sorbet, and in another shot used a combination of real and artificial ice cream to create a melted look (overleaf). Artificial ice cream was used exclusively in the setup of nine cones featuring different flavors (page 65). Using real ice cream for that shot would have taken many more hands to produce that many scoops at once.

Shooting with Carol is always an experience. Arriving at her studio for this shoot, I was greeted by her assistant Carl, her four-year-old son Alex, and Remus, a white Labrador retriever owned by Carol's sales representative and office manager. Back then, Carol's studio was on Boston's Beacon Hill in an old bookstore, complete with musty woodwork and a balcony. It was an intense three-day shoot, and we had to cope with long hours and many design problems, such as making the ice cream look natural and appealing, rather than perfect with every ridge intact (the latter approach is demanded on ice-cream packaging). By the end of the third day and umpteen changes and new decisions, I started to lose it, so I went into the corner and stood on my head. But afterward, when we saw the finished photographs, we all agreed that the assignment was worth the stress.

Carol used a 35mm camera and high-speed Ektachrome, a grainy film that appeared even grainier when cropped and blown up in these shots. Her imaging was straightforward, and she was well aware of how the film would react to the lighting she set up.

HealthAssurance

Benefits options let you add all the extras you want.

SELECT THE PLAN THAT BENEFITS YOU MOST.

One of the keys to controlling health care costs is directing employees to high quality, cost-effective providers. HealthAssurance benefits can be structured in numerous ways to make that happen. You decide on the benefit structure that makes sense for your company. You might decide to retain your current benefit levels if your employees choose preferred providers, and reduce benefits — a little or a lot — if they choose non-preferred providers. Or you might decide to improve coverage on claims from preferred providers and retain traditional benefit levels from non-preferred providers. HealthAssurance also offers a variety of optional preventive care riders that can be added to your benefits package at reasonable rates. Those riders can help hold down your costs over the long term and be introduced with the new benefit plan to make it more attractive. The choice is yours.

Ice Cream

To photograph the setup of nine ice-cream cones on the facing page, Carol used a 2-foot square banklight with a strobe head set at 900 watts per second. This main light was positioned about two feet from the cones and angled away so that the background—a painted, textured canvas—would go fairly dark (see diagram). A large fill card on the right opened up the shadows. Black cards, or "cutters," were put in front of the banklight to cast shadows on the background and foreground.

Carol pointed out questionable areas on the cones that might need fixing, and I touched up the edges of the artificial ice cream with corn syrup to give them a melting quality. The whole arrangement was fine-tuned and tested with 4×5 Polaroids, but the final shot was made with a 35mm camera so that an enlarged image would emphasize the natural graininess of the film.

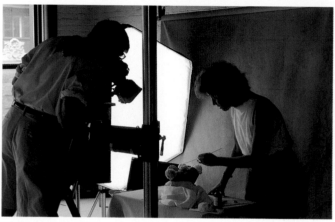

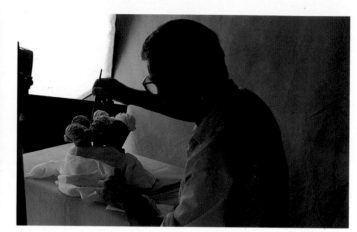

PHOTOS © CARL W. SCARBROUGH

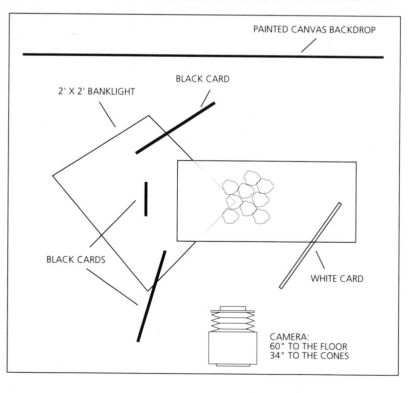

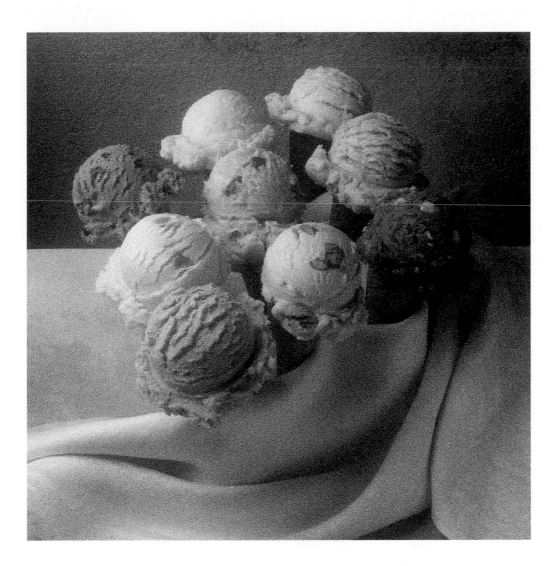

Artificial Ice Cream Step by Step

Mixing powdered sugar and a stick of margarine, I began making a bowl of artificial vanilla ice cream. Adding corn syrup, I kneaded the mixture with my hands. (On the table you can see balls of other flavored artificial ice creams: strawberry, chocolate, butter pecan, and coffee.) When the mixture had a smooth consistency, I shaped it into a ball in preparation for scooping.

Because artificial ice cream dries out in several hours, I usually keep it covered with plastic wrap or a damp paper towel. When it begins to look dry, replacing it with a new batch is easy. Once it is scooped, brushing a ball's ridges with a little corn syrup gives it a slightly melted look that makes it look more realistic.

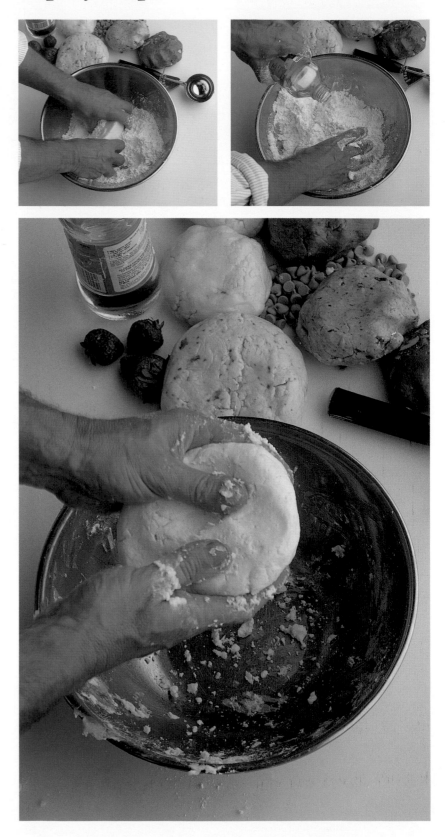

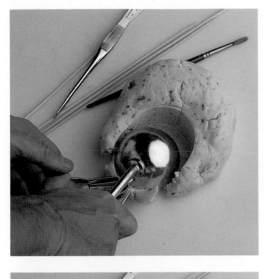

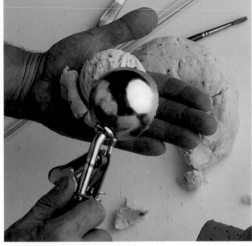

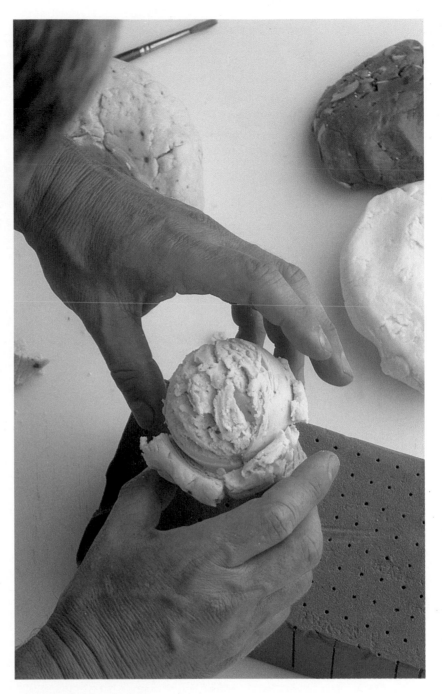

Working with "strawberry" ice cream, I first pushed a cone into a floral oasis, a Styrofoam-like flower holder that I use to keep cones standing upright to protect them from breaking. Then I scooped a ball of ice cream to go on top of the cone.

For regular round scoops of artificial ice cream, I use a conventional ice-cream scoop (I find that the medium size works best), pressing it into the artificial ice cream and releasing a ball from the scoop directly into my hand. This way I can gently place the ball on the cone without crushing it or destroying the ridges on the ice cream.

Artificial Ice Cream Step by Step

To make a lip, or collar, for the ball, I carefully shaved pieces from the bulk mixture, then attached them around the base of the ball in the cone. Finally, I used a skewer (tweezers also come in handy) to design the edges of the ice cream and to create more texture.

Alternatively, if the look I'm after is flat, layered, and textured, as in the photograph of the dish of chocolate ice cream on page 61, I first flatten the bulk mixture. Then I use a professional ice-cream spade (as opposed to a conventional scoop) to create texture while scraping the top edge of the mixture. For the chocolate ice-cream dish, I made three flat pieces and fitted them over a Styrofoam ball, being careful not to touch the ridges. Next I used a wooden skewer to create more texture. (The same technique for making layers or folds can be used with real ice cream; just use dry ice as a base, instead of a Styrofoam ball.)

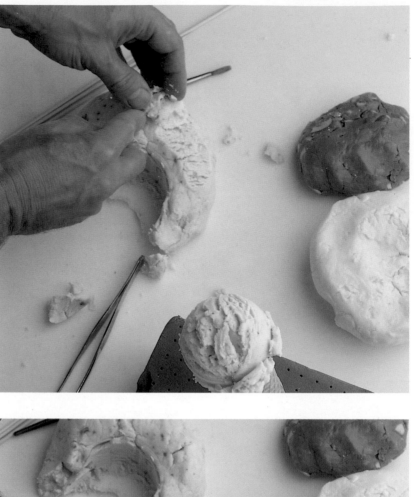

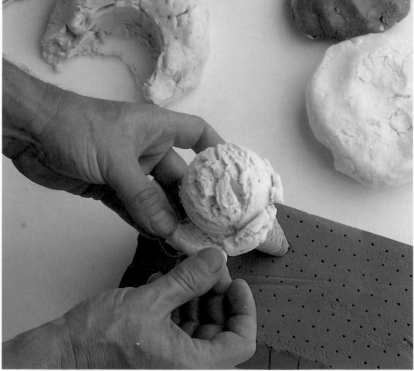

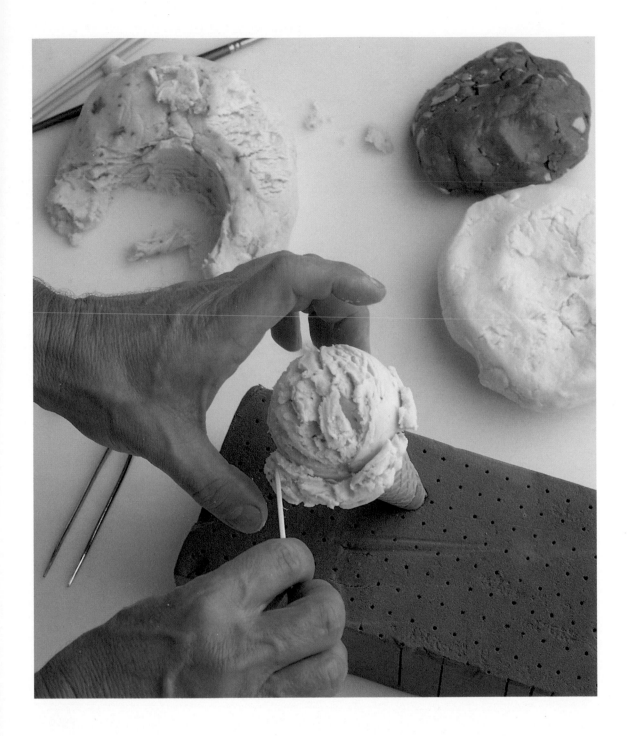

TECHNIQUES FOR STYLING ICE CREAM

EQUIPMENT

Regular ice-cream scoops: small, medium, and large

Zeroll ice-cream scoops: small, medium, and large

Ice-cream spades (with sharp edges): small, medium, and large

Spatulas

Dry ice

Strainer for holding dry ice

Gloves for handling dry ice

Hammer for pulverizing dry ice

Small bowls for holding pulverized dry ice and scoops

7-inch tweezers

Wooden skewers

X-Acto knife

Straight-edge razor blade

Several 5-gallon containers of ice cream for each flavor

SCOOPING REAL ICE CREAM

Always keep your equipment dry, and use cold equipment (including the dishes that hold the scooped ice cream). Use ice cream directly from the freezer. You must work rapidly and have an assistant. (Have artificial ice cream on hand to make stand-ins.)

Starting with a 5-gallon tub of ice cream, begin scooping with a cold, dry scoop in a circular motion. *Don't stop*, or you won't get the desired ridges. It might take several tries to get a good-looking scoop. Have your assistant hold a strainer of dry ice over the ice cream while you are working to keep it from melting, and return the tub to the freezer as soon as you've finished with it.

If you're using a conventional scoop without a wire release, tap the ice cream out by gently hitting the handle against a table surface to release the ball from the scoop. With Zeroll scoops, quickly and gently push the ice cream into the cone or dish with a wooden skewer, and photograph it immediately.

After you've taken several scoops from the tub, turn the tub upside down, and cut off the carton's bottom with an X-Acto knife or a straight-edge razor. Now start scooping from that end (you should always take scoops from a flat surface). An alternative is to cut the carton in half by first cutting the paper tub, then cutting the ice cream straight across with a large knife or wire.

To make a lip or collar for a ball of ice cream, scoop small, flat pieces of ice cream with a spade, making sure you get good ridges, then place them around a cone or dish with a wooden skewer or tweezer.

RECIPE FOR ARTIFICIAL ICE CREAM

1-pound box of confectioners' (powdered) sugar

1 stick (8 tablespoons) margarine

¼ cup light corn syrup

In a mixing bowl, combine all the ingredients. Mix them with your hands, and knead the mixture until it is smooth. If you make it in advance, wrap it in plastic and store it in the refrigerator. Take it out the night before to allow the mixture to return to room temperature, and knead it just before using. This recipe can be mixed in a food processor or mixer. It must be kneaded five to seven minutes for proper texture. Its consistency should be fairly firm, and it shouldn't crumble when scooped. If it seems too soft, add more powdered sugar.

Variations

Strawberry ice cream: Substitute ½ cup fresh crushed strawberries for the corn syrup.

Chocolate ice cream: Substitute ¼ cup chocolate syrup for corn syrup.

Coffee ice cream: Use a browning agent (such as Kitchen Bouquet) to acquire the desired color.

Butter-pecan ice cream: Use butterscotch syrup instead of corn syrup, and add nuts.

Pastry

Whenever possible, use a natural approach to shooting food. This pie is filled with real apples —I didn't resort to using mashed potatoes or oatmeal.

RICH IN NOSTALGIA and soul satisfying, apple pie evokes a happy replay of memories. Photographer Brian Hagiwara and I decided to bring back this delectable reminiscence through photographs. Experimenting in his studio in New York City, we wanted to come up with a new approach to an old favorite. Pastry appeals to both of us, so we focused on the idea of photographing the popular American apple pie. ◁ We thought about how to make the crust look flaky and appetizing and came up with a plan: A short time in the oven would give the pie the right color; then we would move it around on the set and work with the lights to find the best angle for showing off the pie's curves and indentations. Although mass-produced pastries (product pies) need to look perfect on film, we wanted to picture this apple pie in a more casual and homey way. We designed the shot to feature the pie in the foreground, accompanied by a bowl of apples, a glass of cider, several tarts, and maybe a jar of apple butter. ◁ With this picture in mind, I went on a buying spree, shopping for the most "photogenic" apples. I hit my favorite haunt, the farmers' market in New York City's Union Square, where I find many of my special ingredients and produce when they are in season. Because it was autumn, there was a good selection of various apple species: Baldwins, Cortlands, Empires, and Spencers. I looked for apples with leaves on the stem, apples with character. (At other times of the year, I have to glue leaves onto the apple stems.) ◁ After raiding Brian's apartment, as well as the apartments of friends, for "apple things," Brian and I assembled enough bowls and a container for the pie. We definitely over-accessorized the set. I always wind up with more than I need. I call it "the extravagance of food styling." ◁

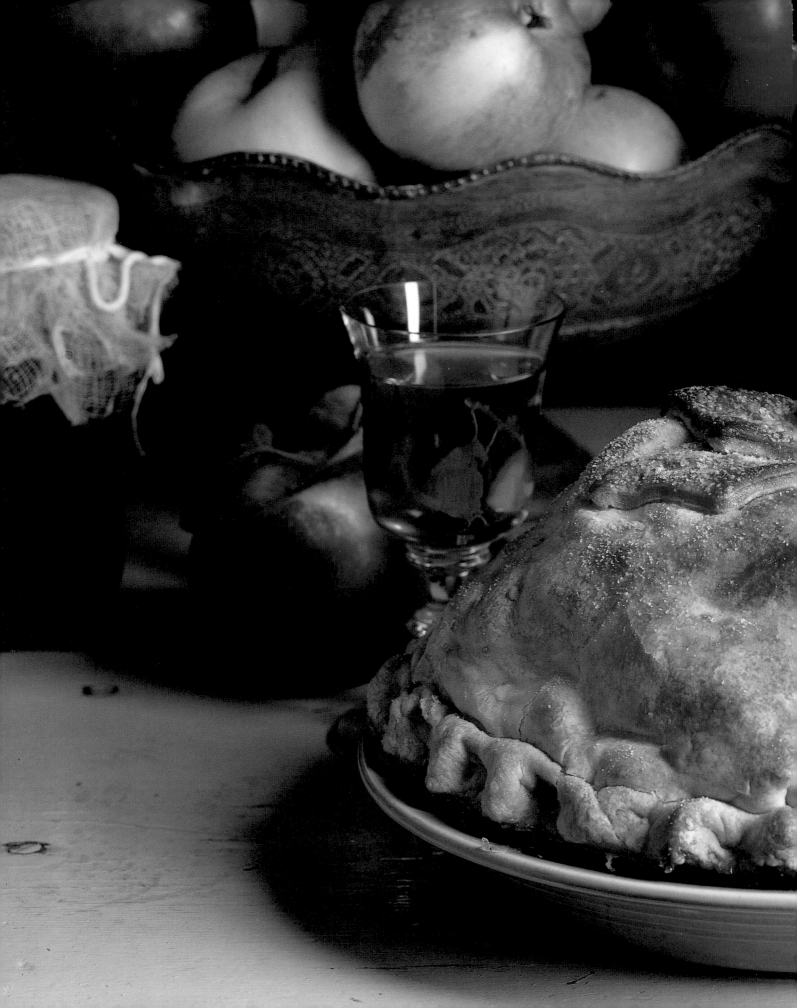

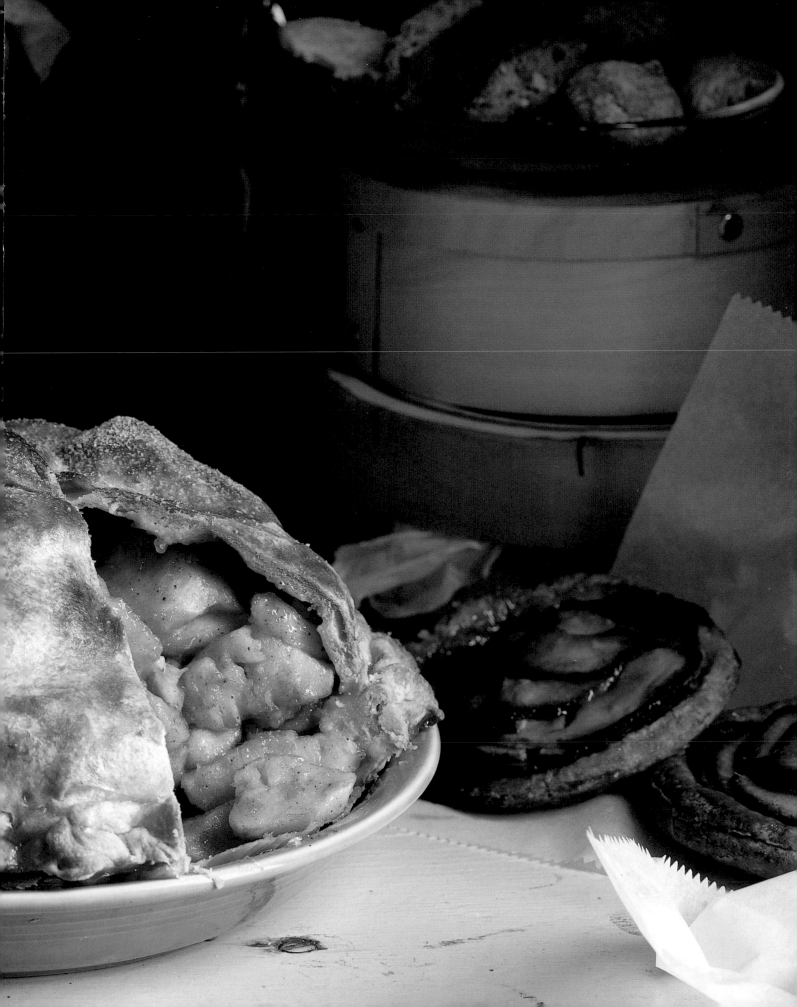

Pastry

Putting the shot together, we let our minds go free. In this case, we had the luxury of being the designers, the art directors, and the clients. Some things I baked, such as the pie, while local bakeries provided us with such special goodies as apple cookies with nuts, and apple tarts.

At 8:30 the next morning, everyone was on the set. Brian's assistants set up the lights while he took exposure readings of each object in the scene, and we decided on the final composition. I arranged the props for the shoot, considering the form, color, and height of each object. The final composition looked good.

Next we shot Polaroids of the set so that we could make all our final changes before the shoot actually began. Brian says "You need Polaroids with food photography.

You can put a piece of cheese down, for instance, and see it one way, but the camera might capture a whole different angle, so that it doesn't even look like cheese."

He decided he wanted a darker background for a more chiaroscuro effect. We had researched old-master paintings of still lifes, and Brian said, "this style is more appropriate for the subject matter. I wouldn't use this kind of lighting and attitude if we were shooting ice cream or Japanese food. But apples are organic and old-world in feeling. I think we want a kind of Spanish still life in lighting and theme."

I wanted to keep the shot simple and decided to cut a small wedge out of the pie. Brian shot the scene both ways: with and without the cut wedge. Our favorite choice was the cut pie (overleaf) because it was more interesting visually.

We approached the shot as a design problem. First the project was all about apples. Then we got creative and began looking for something spontaneous, yet still paid close attention to the details that best described and enhanced our theme.

Shooting with a 4×5 Sinar, Brian used Ektachrome 64 because his strobes work best with this film. He wanted a painterly effect. "I used the most basic light," he said, "softbox lighting from the side that suggests the studio effect of north light on a still life. Sometimes," he pointed out, "the shot is more about composition and lighting than the food itself."

We checked the Polaroids once more, and Brian came in a little closer with the camera. We used no tricks here, and approached the scene naturally—just the way it looks—apple pie, simple and honest.

BRIAN HAGIWARA

Starting out as a fine-art photographer in California, Brian Hagiwara had his first one-man show in New York City in 1978 at Castelli's uptown gallery. Other shows soon followed in New York City and Paris. In 1979 he moved to New York and did portraits and group photos for record-album covers. Brian did photography for Mary Shanaham at **Rolling Stone** *magazine, and she had a strong influence on his career. When she became art director of* **Cuisine** *magazine, she used photographers who had never photographed food before, which launched Brian as a food and still-life photographer. Today food and still lifes make up ninety percent of his work. "I used to do a lot of location work, build huge sets, and use lots of color. Lately, my format has gotten bigger and the objects have gotten smaller. So, now I am dealing with very small things with big cameras."*

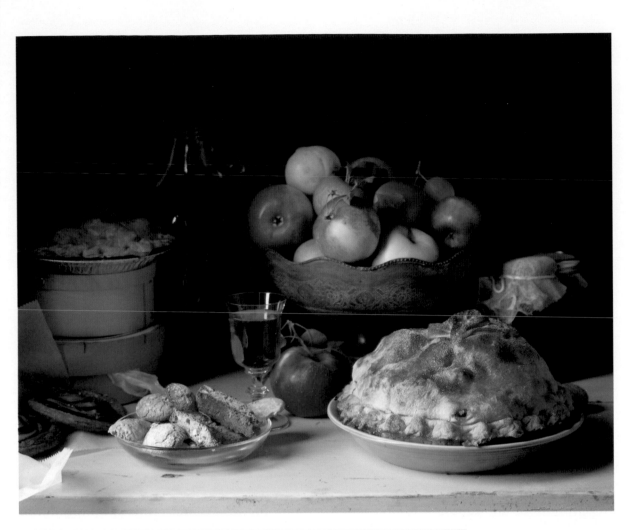

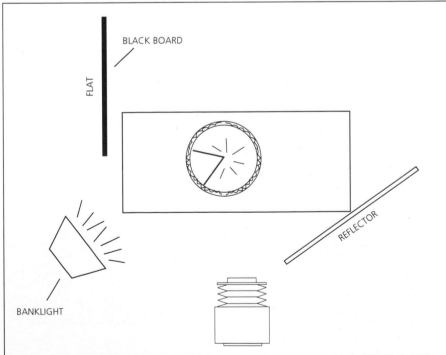

BLACK BOARD

FLAT

REFLECTOR

BANKLIGHT

Pastry Step by Step

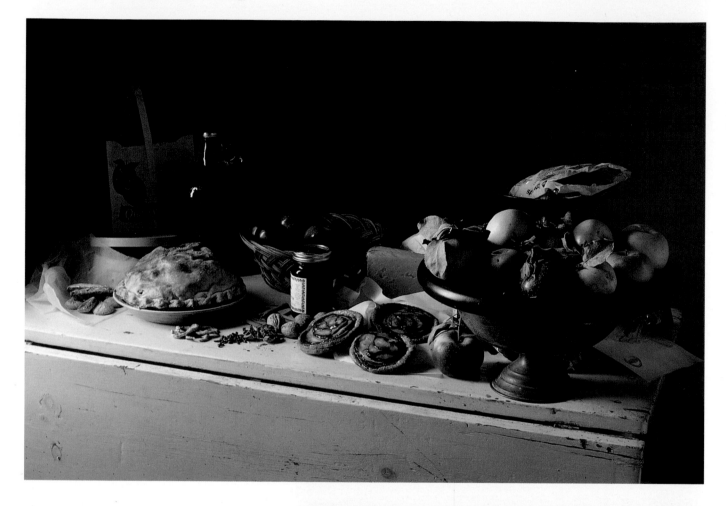

First, we placed the props and ingredients on the set just to give us an idea of what we had to work with (above). Up to this point the project had been a visual concept, an idea in our heads. Now it started to become a working reality, a sketch of the final shot. Brian checked the lights and took meter readings for correct exposure. I looked at the food, deciding what angles on the pie, tarts, and apples would work best facing the camera, right down to the leaves on the apple (right). There were a hundred decisions to make. What bowl would look best for the apples? Was the pie clearly the focal point? How should we lead the eye toward it?

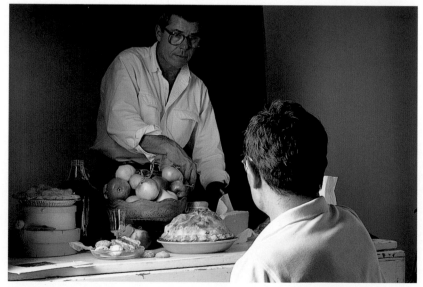

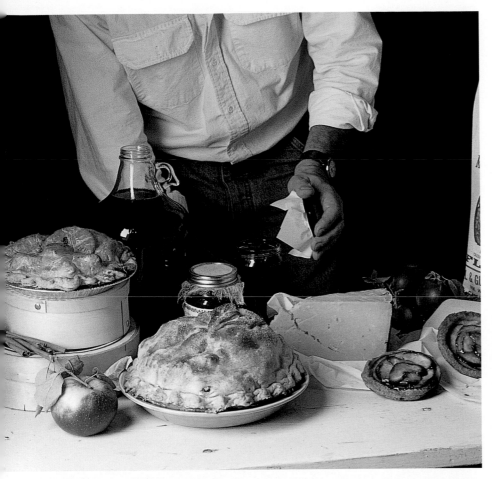

Decisions were made about everything that appeared in the shot. What should be changed? What should we eliminate? Attention was given to each item on the set.

The tarts needed to be shinier, so I put a glycerin glaze on the apples. Then I replaced the top of the new jelly jar with a piece of stained cheesecloth to create more of an old-world feeling. Next we eliminated the spices as well as the cheddar cheese, the bowl of nuts and crab apples, and the bag of flour—these extra elements were too distracting.

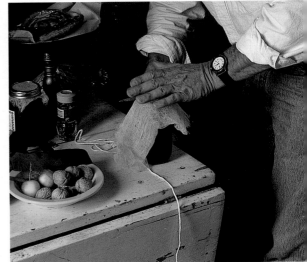

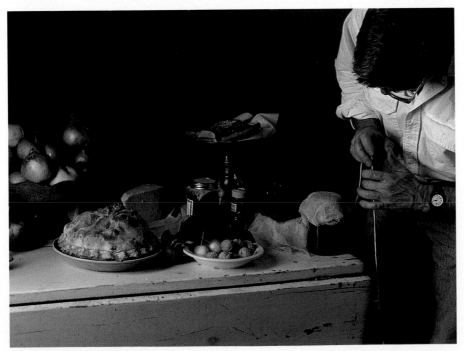

Pastry Step by Step

The pie had to be sliced to show the apples inside. I started at the top, using a straight-edge razor blade (right). This rendered a clean cut, preventing the crust from crumbling. I removed the wedge of pie (below), careful not to disturb the clean edges of the remaining pie, and placed it on a dish.

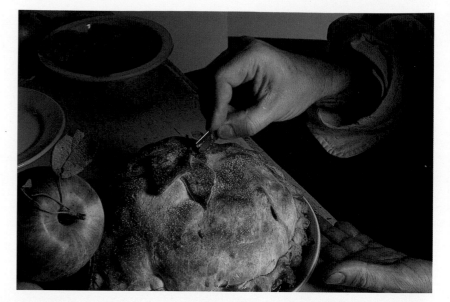

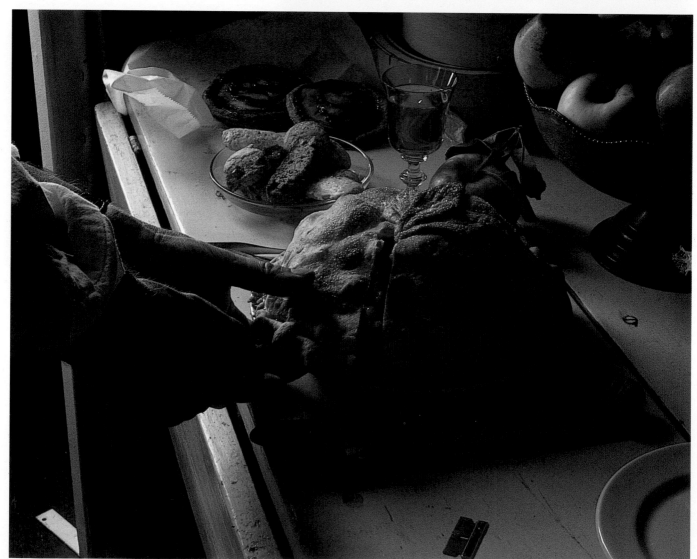

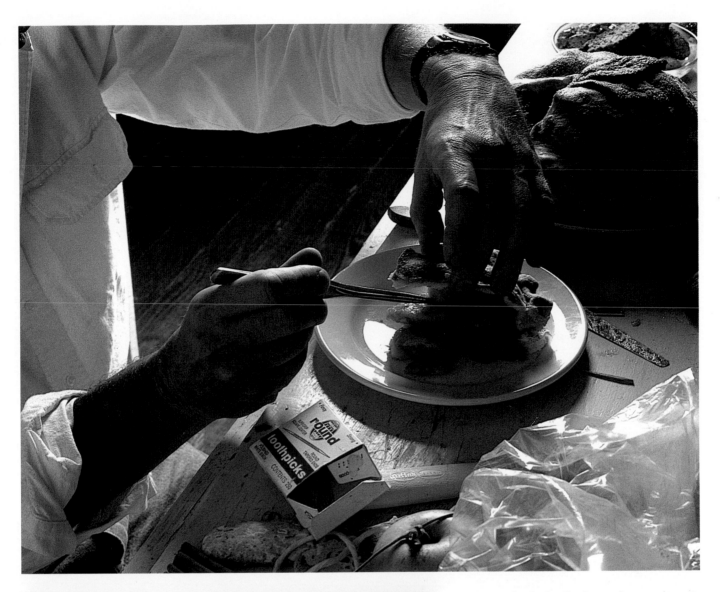

Everything looked good, yet the pie didn't look as full as I had hoped. I added pieces of apples from the wedge to give the pie a fuller look (above).

Brian took Polaroids for us to look at and discuss (left), rather than making us hang upside down and judge the scene through the camera. Sometimes the photographer's and stylist's jobs overlap, giving each a chance to see something the other might have missed. I like working this way because it gives both people a sense of the total picture.

CRUSTS

Preparation

Dough for the crust should always be made ahead, then wrapped in plastic and refrigerated until needed.

Measuring

It is best to over measure, using 1½ times the amount of dough for each crust.

Baking

Bake all pie crusts at the studio. Prebaked crusts are too fragile and difficult to transport.

Temperature

When using cold dough from the refrigerator, leave it out until it reaches room temperature. Always work with moist dough, so don't leave it exposed to the air for long periods of time.

Pan for Baking

The crust will brown better and more evenly in an aluminum pan.

Fruit Glaze

For fruit-filled pies, drain most of the juice from the pie using a baster, and mix the juice with about 1 teaspoon of arrowroot. On top of the stove, cook the mixture slowly until it is thick enough to use as a glaze. This may then be dipped or brushed onto the fruit to create highlights.

CUTTING THE PIE

To show a single piece of pie, it is preferable to cut a wedge that is slightly larger than what you want to appear on film. If the pie is to be the main subject with the wedge removed, cut the piece slightly smaller than required.

Cutting a Wedge

If a single wedge is desired, the pie may be filled with mashed potatoes and baked. When it is cool, cut the desired wedge, remove a little of the potato from the surface facing the camera, and replace it with the desired filling, such as apples or cherries, using the potatoes as a base and support for the fruit.

Cutting Tools

When cutting pastry or wedges from a pie, use a double-edged razor blade or X-Acto knife, wiping the blade frequently. You may also use the blade or knife to pick gently at the pie crust to create additional flaking.

Support for Wedges

For individual pieces, make wedge-shaped supports using disposable aluminum pie pans cut slightly smaller than the actual piece. This will support the back of the pie, and the wedge won't fall.

Other Tools You Will Need

Tweezers, toothpicks, straight-edge razor or X-Acto knife, disposable baking pie pans, and aluminum foil.

DOUBLE-CRUST PIES

Filling

To control of the height of the pie when it isn't going to be cut, fill the pie with mashed potatoes (you can use instant potatoes). Oatmeal can also be used as a filling.

Baking

Bake the pie at 425 degrees for 45 minutes to 1 hour. Shield areas that are browning too fast with small squares of aluminum foil.

Designs

Aspic cutters may be used when a design on the crust is desired on a nonproduct pie. It is best to create a stencil or paper pattern before cutting the crust. Place the stencil on the rolled-out dough, and cut the shape out with a knife. Brush the bottom of the piece you're adding with water, and put it on top of the pie crust. For a glazed look, brush the crust with milk or cream and sprinkle with granulated sugar.

Special Effects

Have fun with flaming, pouring, and splashing techniques. Find time to experiment—it keeps you fresh and open to new ways of preparing and presenting food.

PROBLEMS ARISE when photographers are asked to illustrate moving objects; then special techniques to create illusions are required. Understanding the concept behind a special effect and playing with ideas ahead of time for producing it can help you troubleshoot common requests in food photography. Although a concept might work on paper, translating it to film is another story. If you devise methods for your own special effects before you're asked to produce them on assignment, you'll have a better idea of what works and what doesn't, and be able to communicate this to the art director or client. I have found that experimentation is a big part of food photography and styling. Whether you do it in your own kitchen or in the studio, you have to try out different techniques in order to find out if they work. Often I just start with a concept and let it unfold and develop, keeping an open mind and a keen eye for what succeeds and what doesn't. What follows are some techniques I have used for flaming, pouring, and splashing effects. A flaming shot is usually done by pouring alcohol—liquor or brandy—over the food, usually a warm dessert dish. Sometimes I use lemon or almond extract, and, as you'll see, I've even used lighter fluid, depending on what color flame I wanted. Pouring means lightly covering a food with a liquid—for example, pancakes or almost anything that requires syrup or gravy. Splashing refers to creating action with liquids. You can drop something into a liquid, use fake acrylic "splashes" to represent the effect, or photograph a combination of both. The best part of experimenting with special effects is that they can really be a lot of fun. When else do you give yourself permission to slosh around the floor in tomato soup, or set things on fire? Let your creative juices flow, and see what happens— you'll probably discover something you like and can use someday.

Red-Hot Tomatoes

The flaming tomato was a shot Jack Richmond and I did on a day we had set aside for experimenting in the studio. Tomatoes were in season, and ours had stems—they were gorgeous. These summer fruits triggered our idea to show a tomato falling into a black bowl of tomato puree.

Our first approach was actually to set the soup on fire. We used a black background for drama. The bowl was propped up on a tripod. I poured lighter fluid over the top of the soup, lit it, and dropped a tomato. As it fell, it triggered a light sensor (positioned above the bowl) for tripping the shutter, so when the tomato hit the soup, we caught the splash on film.

We weren't satisfied with the results from this technique—they weren't dramatic enough—so I tried covering the tomato with lighter fluid, lighting it, and then dropping it into the soup. The flame from the tomato falling was recorded on film and made a much more exciting visual.

We did this several times, and each time Jack made me clean the bowl, as the black ceramic picked up smudges and fingerprints. I had no idea what he was seeing, but I found myself with my pants rolled up, standing in a puddle of tomato puree.

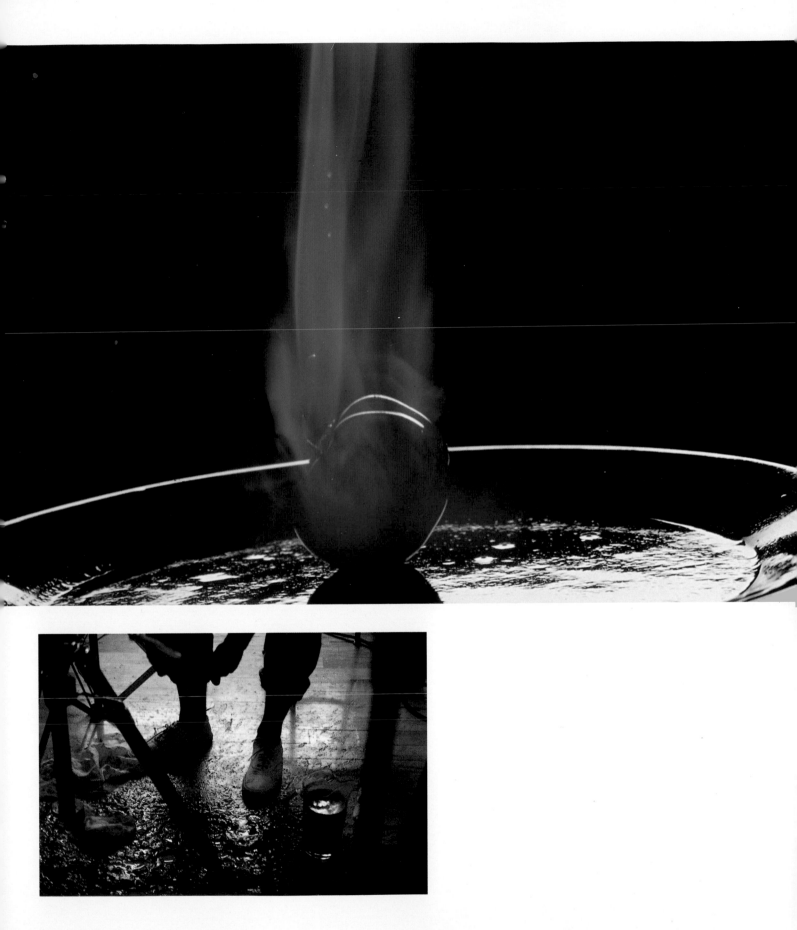

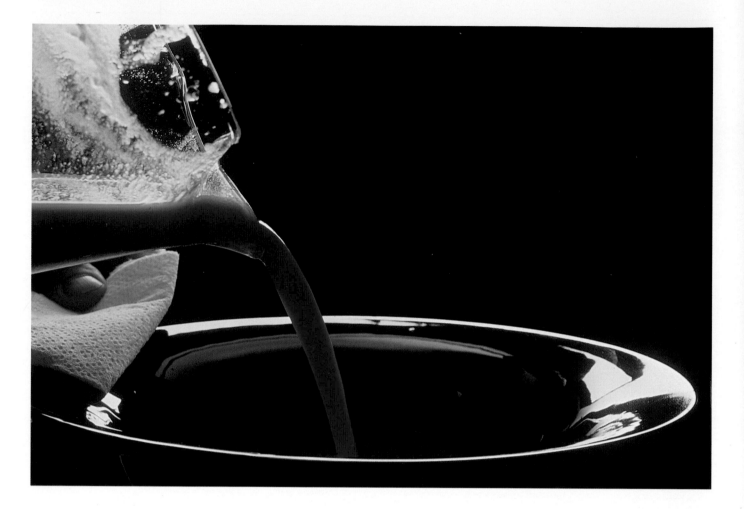

Pouring the tomato puree into the black bowl made an interesting graphic shot in itself (above). As I was doing it, Jack saw it and liked the image. We decided to do three shots just of the pouring. After that, I held the tomato by its stem with tongs, then poured lighter fluid over it and lit it immediately (right). Dropping it made some fun pictures.

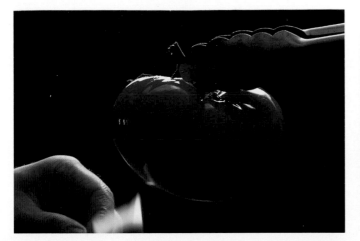

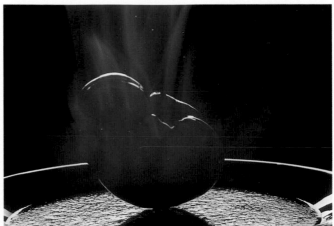

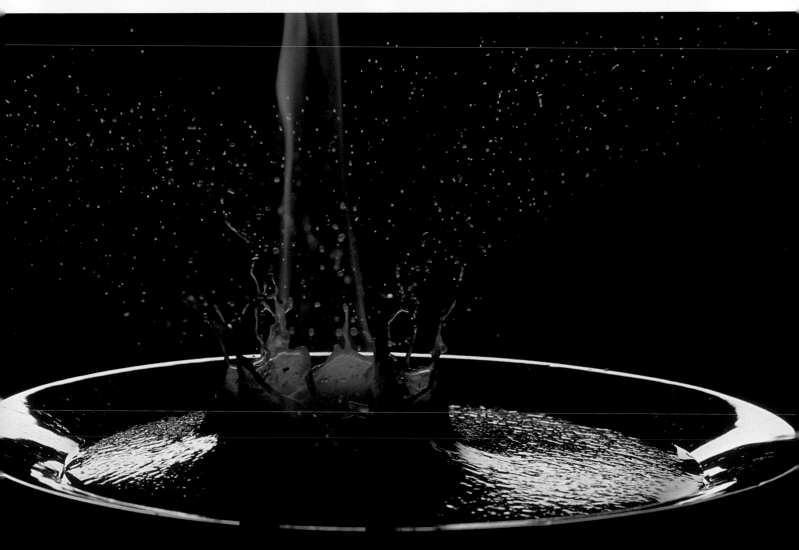

A Flaming Finale

Another project started out with Jack and me thinking of different ways that we could present a dinner for two. We came up with the theme of sensual food. As a food writer, it was easy for me to come up with recipes and try to sell the idea as an editorial package. We ended up producing a camped-up fantasy: a kinky dinner party for two.

Besides shooting the whole dinner, we wanted to have fun with the different components, expanding and developing them separately to see how we could create an enticing picture of each dish. The overall shot (below) was ultimately much too busy. When we cropped into the different elements—for example, the image of the soup (overleaf), the mirror reflecting the flame and glasses, and the wine and champagne bottles—we did get some nice images. While flaming the steak, I got a little carried away and accidentally set fire to a large sprig of dried flowers.

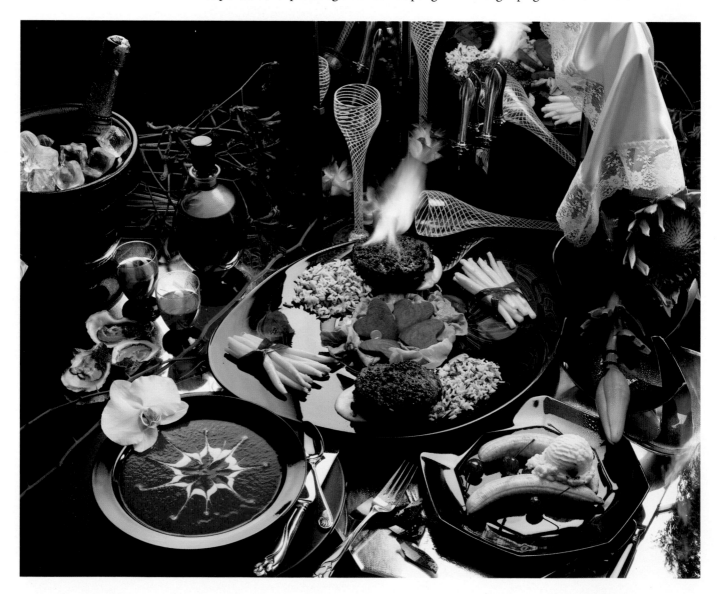

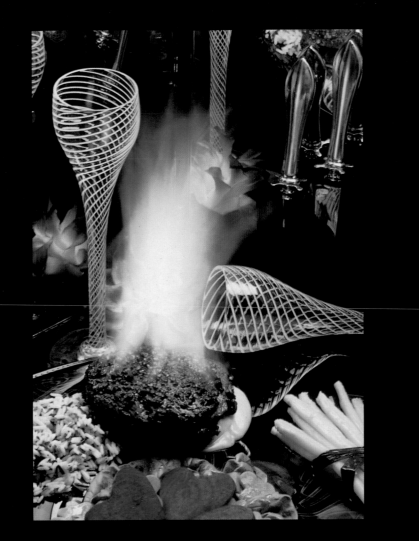

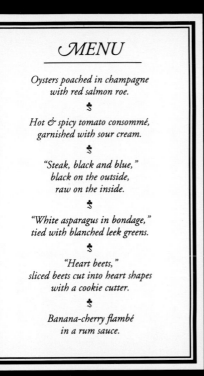

MENU

Oysters poached in champagne
with red salmon roe.

❧

Hot & spicy tomato consommé,
garnished with sour cream.

❧

"Steak, black and blue,"
black on the outside,
raw on the inside.

❧

"White asparagus in bondage,"
tied with blanched leek greens.

❧

"Heart beets,"
sliced beets cut into heart shapes
with a cookie cutter.

❧

Banana-cherry flambé
in a rum sauce.

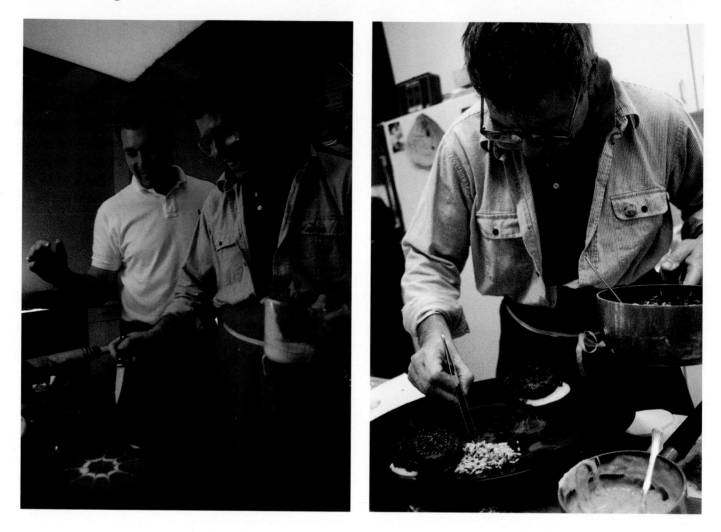

Styling this set was an exercise in balancing kitsch with elegance. One of the props was an expensive broken bowl I found at an exclusive home-decorating store (they gave me the bowl). The dinner plate was a one-of-a-kind, handmade, five-hundred-dollar dish I borrowed for the shoot. As part of our dark theme, we wanted most of the items to be black, but I had pink napkins specially made from a satiny fabric and trimmed with lace. Mirrors in the background reflected the sections of the set.

Preparing the food, I used tweezers to do final touch-ups on the rice. While Jack watched, I applied sour cream to the tomato soup, using a knife to pull the white cream through the red soup and create a spiderweb design. As a last touch, I placed a flower on the rim of the soup bowl.

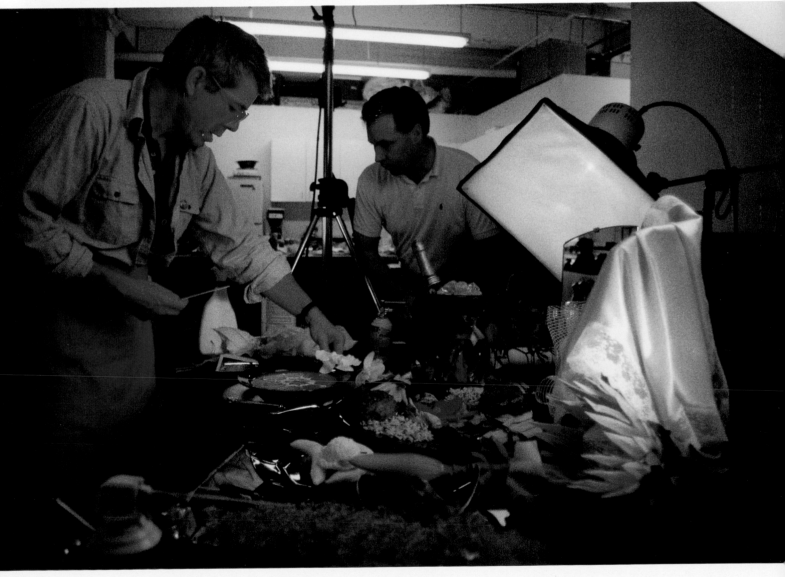

A Flaming Finale Torching the banana-cherry flambé was a fitting finale to this affair. A glass pan was placed over a small burner. Within it corn syrup was brought to a boil with the fruit. After igniting a ladle of lighter fluid and pouring it over the dessert, I transferred the bananas and cherries to the set and poured more rum sauce over them.

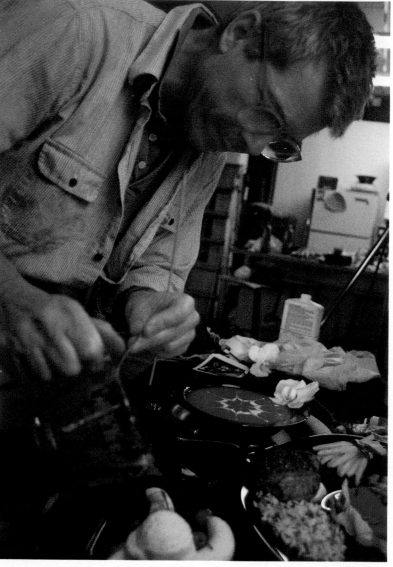

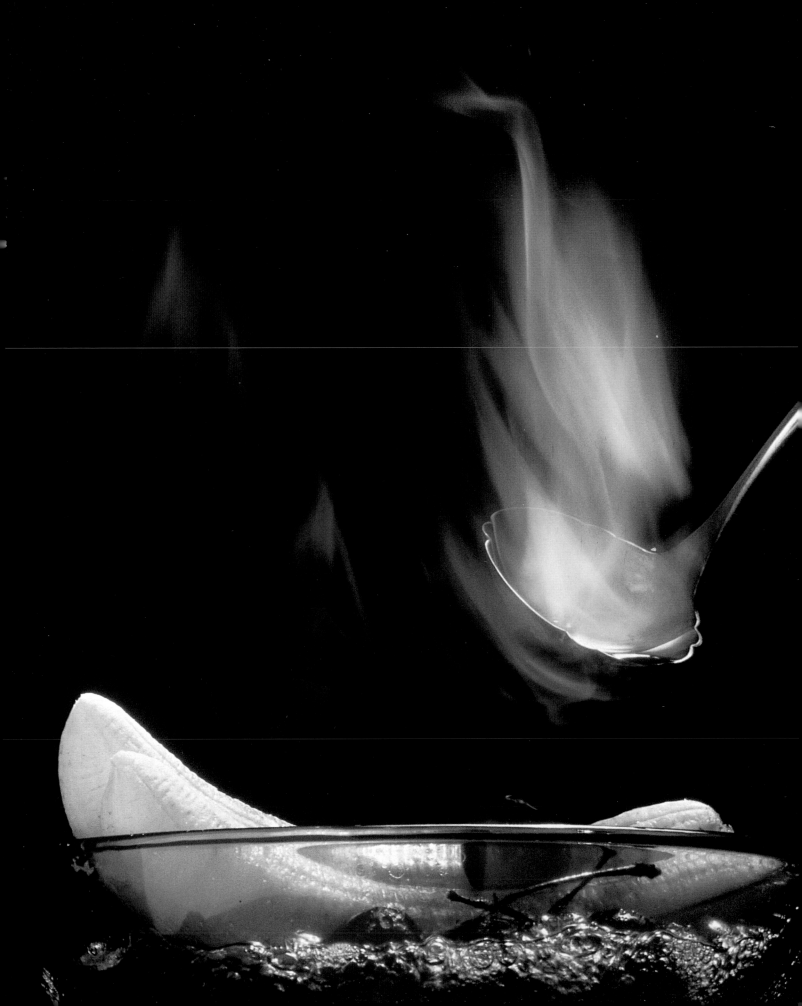

Pouring 101

Styling a good "pour" of syrup onto a plate of waffles takes a bit of finesse, so I decided to use my technique to illustrate one of my promotional mailers. Jack Richmond agreed to photograph the piece for me at his studio. I arrived loaded down with my usual gear and an ample supply of packaged waffles, bottles of dark corn syrup, and several pounds of margarine (its color is more photogenic than butter). I immediately put the corn syrup in the refrigerator to thicken it. Making a pour flow evenly is simpler when the syrup is cold.

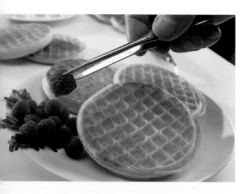

Jack put an 80×80 cm banklight and one spotlight over a white tabletop, creating an ambient glow on the set. After lightly toasting the waffles, I let them reach room temperature and arranged three on a plate. I decided *not* to spray them with acrylic, a common practice in food photography to prevent syrup from soaking into the waffles. Using tweezers, I added a garnish of fresh raspberries and raspberry leaves (top photo at left).

Then I carefully placed pats of margarine on the waffles. With a propane torch, I heated a small spatula and touched it to the margarine pats to melt their edges (bottom left). You must do this quickly, being careful not to melt too much of the pat.

Jack used a small 35mm camera, shooting close to the set. Although it was a tight shot, he zoomed in and out to get variations in the composition. Meanwhile, I created a nice pattern of syrup on the waffles, pouring slowly to control the flow and not create a puddle. We repeated the whole process several times (using new waffles and new butter pats) to make sure we got a good shot.

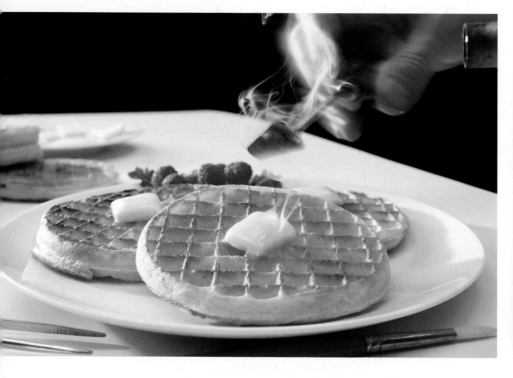

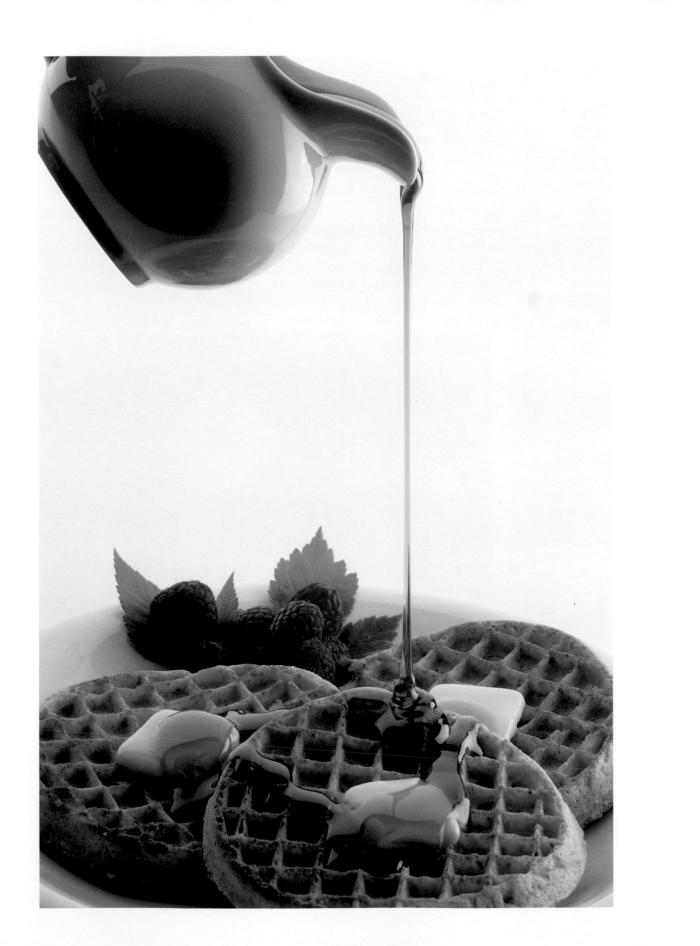

Liquid Assets

The photographs in this section represent technical, rather than food-styling, effects and were styled directly by the photographers themselves: Barry Seidman, Chris Collins, Steve Tague, and Michael Watson. They all have a knack for construction and were able to create interesting shots on their own, using a combination of techniques that they perfected themselves.

Barry Seidman's client, Schweppes, asked him to shoot a splash coming from a glass into which a can of iced tea was being poured. Since this effect wouldn't ordinarily occur, Barry had ready-made acrylic splashes colored to match Schweppes' iced tea. He then measured the right amount of a pour to fit inside the can and filled the glass with ice cubes, the lemon, and iced tea. When everything was set up, he hit the glass with a little air from an air gun to make some natural splashes and photographed the setup using a slow shutter speed so that the real splashes would blur slightly.

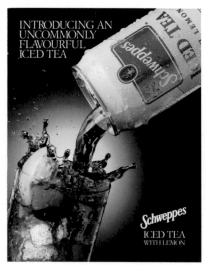

COURTESY CADBURY BEVERAGES, INC.

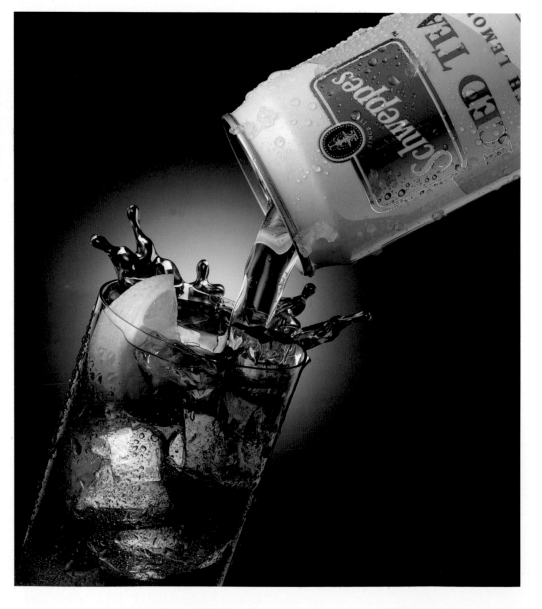

A New York generalist who shoots many liquor ads and celebrities, Barry shot this photograph for Rose's Lime Juice much as he did the ones for Schweppes. The assignment was to show a pour from the bottle into a glass, creating a large splash. Again, he combined an acrylic splash with real liquid in the glass and a burst of air to make it look realistic.

"While I was at the camera, someone poured lime juice from a bottle rigged to a stand that swiveled, producing a pour that hit the same spot in the glass each time. We knew exactly how much lime juice should go in the bottle so that, when it was turned over, the pour was consistent. The real splash was made with a can of Dust-off (compressed air) that had a long hose with a nozzle on the end. We put the nozzle four inches above the glass, and as soon as the pour hit the glass, we hit the liquid in the glass with the air that made the splash. At the same time, I hit the shutter. This shot took fifty sheets of film, as opposed to five sheets for the Schweppes' shot, but I as you can see, I got what I wanted."

The Limessence of Rose's... simply splashing.

The Cranberry Rose: Cranberry Juice, Club Soda*, and a splash of Rose's Lime Juice.

*Vodka can be substituted for Club Soda. Hint: A splash equals 1 teaspoon.

COURTESY MOTTS U.S.A.

Photographing a champagne pop is similar to shooting steam—in both cases you're working with something light and ephemeral that must be caught by the camera. New York still-life photographer Chris Collins pulled out his creative thinking cap to photograph a cork popping out of a champagne bottle. He hired a modelmaker to drill a hole in the bottom of the bottle, then hooked it up to an air hose and a compressor. With a cork in place on the empty bottle, he pumped air into it until the cork popped. Alas, all he got was a mini-vapor burst.

He then turned the bottle upside down, inserted an eyedropper of water into it, and quickly corked the bottle before it leaked out. This time when the compressor was turned on, it caused the small amount of water to vaporize. A sound detector, positioned (after much experimentation) at just the right distance from the camera, triggered the strobes when the cork exploded, and the experiment was a success at last.

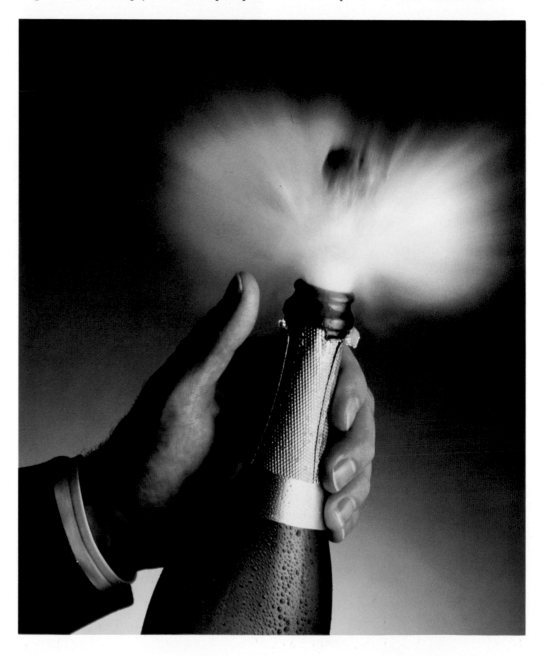

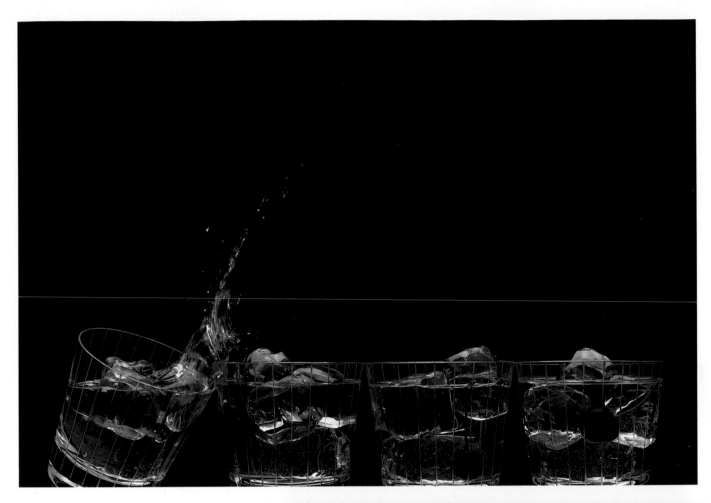

Steve Tague is a still-life photographer whose specialty is home furnishing and antiques. His client, a graphic designer working for a glassware company, needed a realistic splash for a packaging design. Steve's original plan was to fix three glasses in place, then build a platform to bump one glass against another. The idea was that when two glasses bumped, liquid would splash out of the glass.

But what was supposed to be a splash became a slosh. Twelve hours later, in desperation he tossed a cherry that landed by chance in the glass of liquid and voila! he had his perfect splash—on Polaroid. Two days and fifty sheets of film later, he got his shot. Because it was successful, he used the same method with an olive. Each attempt required a complete clean up of the set, and a change and refill of the glasses.

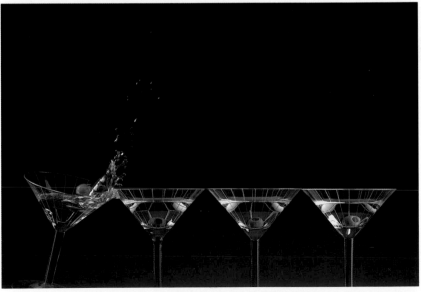

Liquid Assets

The image Suntory devised to promote their new drink, "Mohala Monsoon," included palm trees and glasses caught in a monsoon's strong winds. Michael Watson, who specializes in food, product, and location photography, got the assignment and

The crew built palm trees on the beach, and Michael was pleased with the perspective achieved—the client's layout was a perfect mirror image of the final ad.

shot it in St. Croix. Originally, he planned to do it in his studio, but he was also asked to photograph a model holding the same glass on location. With a model involved, the background scale had to be much larger, so Michael and his crew went on location. The most difficult part of the assignment was getting the glass (made by New York Glass Works), the acrylic pour (made by Starbuck Studios, a modelmaker), and the palm trees all to lean in the same direction.

The crew built tree trunks from twelve-foot plastic pipes and cemented them into the ground. Fresh palm branches were attached to the trunks with wire, and their "blowing leaves" were dried overnight to "curve in the wind." After brown cloth tape and artificial coconuts were added to complete the assembly, guide wires were staked into the ground to tilt the trees and simulate a full-blown tropical storm. Fortunately, a real storm appeared that August and supplied a dark sky, so the client got an exact copy of their layout with no retouching needed.

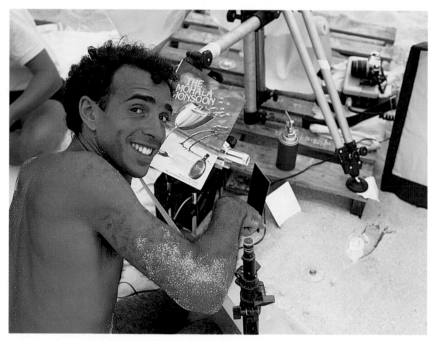

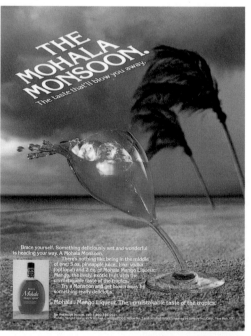

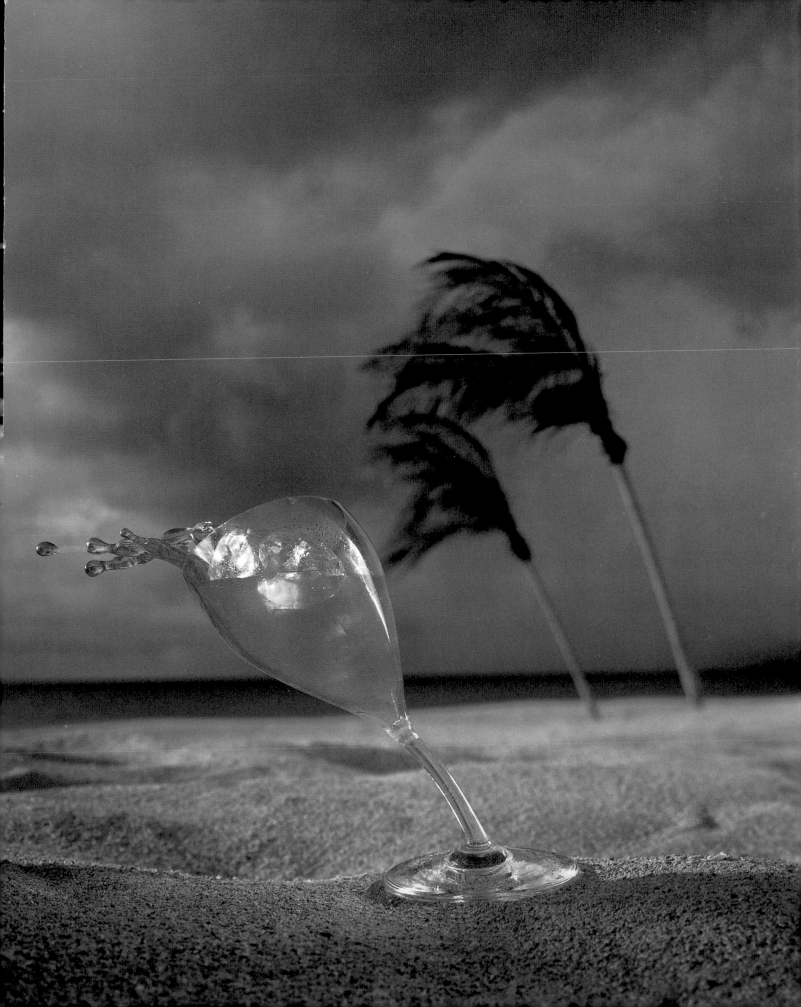

Techniques for Flaming, Pouring, and Splashing

FLAMING

Equipment

Set up a table close to the set to hold the special equipment you'll need:

Small metal container for heating and pouring alcohol

Small burner

Pot holders

Matches

Fire extinguisher

Alcohol

Use regular brandy or cognac, lemon or almond extract (80-proof or higher for best flame). Heat it until it is warm on a burner or in a microwave for 5 to 10 seconds, then ignite it. If you are flaming a dessert—for example, a steamed pudding—heat it first.

Color

For a yellow flame, use lighter fluid. Alcohol burns blue. Proceed cautiously when using any flammable substance

POURING

Creating a champagne pour, such as the one on the first page of this book, or a beer pour involves putting a certain amount of foaming "head" on the drink. Learning to do a pour takes confidence and a "just do it" attitude. Sometimes you can pour a head on the first try; sometimes it takes several tries. Just keep practicing. If the shot is for editorial use, you can be less critical than if you're doing a beer shot that has to have just the right amount of foam.

Champagne "pops" happen so fast that there is no way to catch the cork in exactly the same place on film. There are some techniques, however, for maintaining enough control to get a shot. The cork can be frozen—that is, pasted or held in place by invisible-to-the-eye fishing wire inside the bottle. Temperature affects pop: If the champagne is cold, the cork moves slower; warm champagne makes the cork fly faster. Some photographers shake the bottle up, making the cork ready to blow as soon as the model's hand releases the cork.

Equipment

A table should be set up to hold the following:

Several clean glasses

Cold liquid for pouring (warm liquid produces too much foam)

Large baster for suctioning excess liquid from a glass

Large bucket into which liquid can be emptied

ACRYLIC SPLASHES

"An art director sometimes draws a layout where a bottle is two inches from a glass, producing a magnificent splash. That's not real life. It doesn't happen," says Barry Seidman. "Five inches from the bottle, it might."

Photographers use acrylic splashes as needed, either ready-made or made to order from a modelmaker. Some of the splashes they make are very realistic. They can be ordered to exact specifications and colored to match liquids. However, according to Steve Tague, if you're familiar with acrylic splashes and look at a photograph closely, you can tell a real splash from a fake one. Acrylic splashes are often very expensive but are sometimes worth having.

At Starbuck Studios, I spoke to Alan Buckley about how fake splashes are made. "We start with the client's original art, usually a drawing," he says, "and turn it into a piece of sculpture, using a solid block of acrylic or a sheet of plastic, bent to shape and carved. The final polishing is difficult because the delicate ends of acrylic splashes are easily broken. Most splashes are made to specification; however, I do rent generic ones."

Shooting on Location and with People

Coordinating people and food is always a matter of timing. With a good prop and food stylist, and a good photographer who understands design and lighting, you can make a beautiful picture.

SHOOTING FOOD ON LOCATION succeeds when you have creative, spontaneous people who enjoy working together. That includes the right photographer and an art director who is into channeling the impromptu excitement the occasion demands. Coordinating people and food with camera work can be chaotic and overwhelming, so when you parachute into an unfamiliar place, it is best to have the logistics of the shoot figured out well in advance. ✈ This chapter covers four different shoots on locations across the country. It concludes with a studio shoot featuring the professional spokesman for Pepperidge Farm, Charlie Welch. This business has taken me from a spring ski picnic atop a 9,500-foot mountain in Utah to a clambake on Cape Cod, and from a balmy backyard in Los Angeles to a sailboat in the Caribbean. I've worked with ordinary people and professional models, and the best part is—I have a great time doing it. ✈ Shooting on location is one of my favorite parts of food styling. To me it means total involvement, and it takes teamwork to pull it off. Personally, it gives me a chance to be especially creative because it challenges me to work with what I've got in front of me. My job is to find ways to resolve the various problems that each different situation presents. I've learned that when I'm on location, nothing goes exactly the way I expect it will, and I have to be very flexible and leave plenty of room for change. ✈

As food editor for *New Choices* magazine, I planned an April spring-skiing feature around a trip that a group of friends and I take each year to Alta, Utah. I thought a ski picnic on a beautiful, sunny day in the mountains would make a good feature for the magazine.

Working out the preliminaries before the shoot was quite challenging. First, I wrote the article and developed recipes for the food. Sara Giovanitti, who designed the magazine, and I agreed that New York photographer, George Carol Whipple, III, was perfect for the shoot because he works well with people on location. I had three jobs: providing props for the location, styling the food, and modeling for the camera.

The logistics of getting the props out to Utah were my responsibility. Sara and I didn't work from any sketches, but we decided on a concept: bright, colorful accessories for a festive look against the white snow. I shipped the props—includ-

ing my ski equipment, a grill, cloth napkins, plastic cups and trays, thermos bottles, and plastic wine glasses—out to Alta via Federal Express. I bought all the food there and prepped it at Alta Lodge the night before the shoot. I also had to rent a snowmobile to carry us and our equipment up the mountain. At 5:00 A.M. I was still attending to last-minute details.

Once everyone and everything were transported up the mountain, the bright colors of the thermos jugs, cups, and food looked dramatic against the snow. The food styling for this shoot wasn't as critical as usual because the event was really the focus here, rather than a "hero" shot of a particular dish.

George and his assistant had selected the location on the mountain. "The shoot was great fun," he says, "and there were plenty of challenges in getting to 9,500 feet with all of that equipment. Everything was brought to the site either in plastic containers and backpacks or on the snow-

GEORGE CAROL WHIPPLE, III

George Carol Whipple, III, was encouraged to abandon his career as a Wall Street lawyer and go into photography by Andy Warhol, who told him to "Take pictures of your friends, George, it is very important." Following that sage advice, George photographs on location for numerous journals, including The New York Times *and* Harper's Bazaar. *Some of his advertising work has been for such clients as American Express and Pall Mall Cigarettes.*

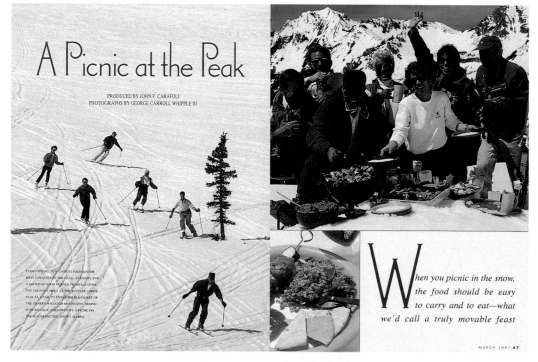

A Picnic at the Peak

PRODUCED BY JOHN F. CARAFOLI
PHOTOGRAPHS BY GEORGE CARROLL WHIPPLE III

When you picnic in the snow, the food should be easy to carry and to eat—what we'd call a truly movable feast

MARCH 1991·**47**

mobile. Even though it was very warm overhead, it was cold below and the batteries on my equipment kept dying.

"We were shooting in a white world on top of ten feet of snow, and there was a lot of light bouncing around. I stopped my 2¼×2¼ camera way down to $f/22$. It was difficult to move the equipment around and, at the same time, not break through the crust of the snow. We put Baggies on the tripod legs so their joints wouldn't rust. The strong sun brought the air temperature to 80 degrees.

"Because the climate was so harsh, we discussed shooting in the valley where the conditions were less extreme, but I felt that it was pointless to fly halfway across the country to shoot in the bottom of a ravine. If we had, the photographs would've looked like they were shot in a studio on fake snow. Plus, I wanted to get to the top of this mountain where the background would show a magnificent landscape."

George thinks that shooting people and food in an environment's natural light makes for a more interesting photograph, even if the light is uneven. He calls this his "best available picture" philosophy.

"Wherever I am," he says, "there is always someone saying, 'we can't do this,' or 'we can't find that.' I always answer, 'what *can* we do—what's the best available picture here with what we've got to work with?' In this case it meant grabbing some people from the lodge, going to the top of the mountain, and throwing everyone together for a picnic in a spectacular setting—in other words, using what we had at hand."

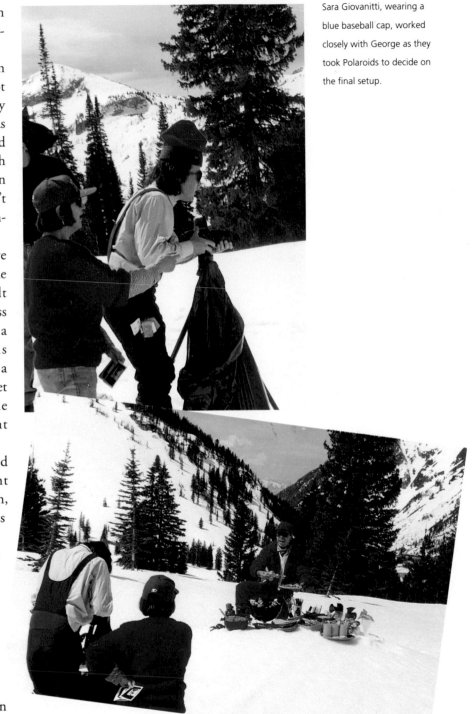

Sara Giovanitti, wearing a blue baseball cap, worked closely with George as they took Polaroids to decide on the final setup.

PHOTOS © BONNIE BILLINGS

105

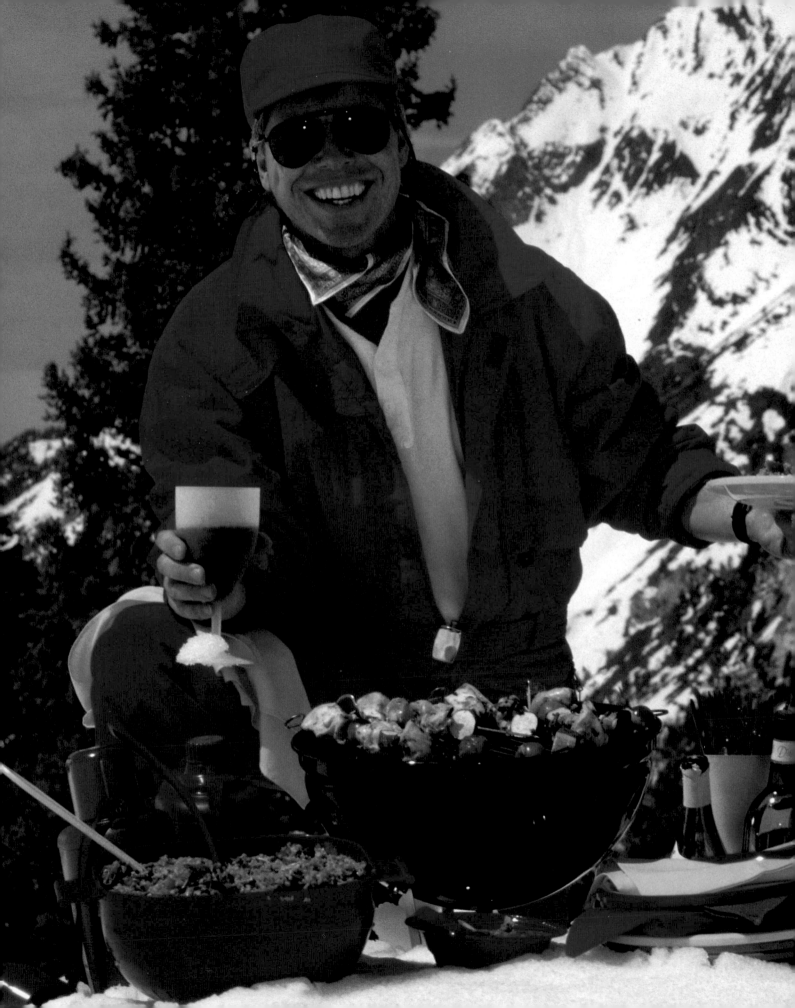

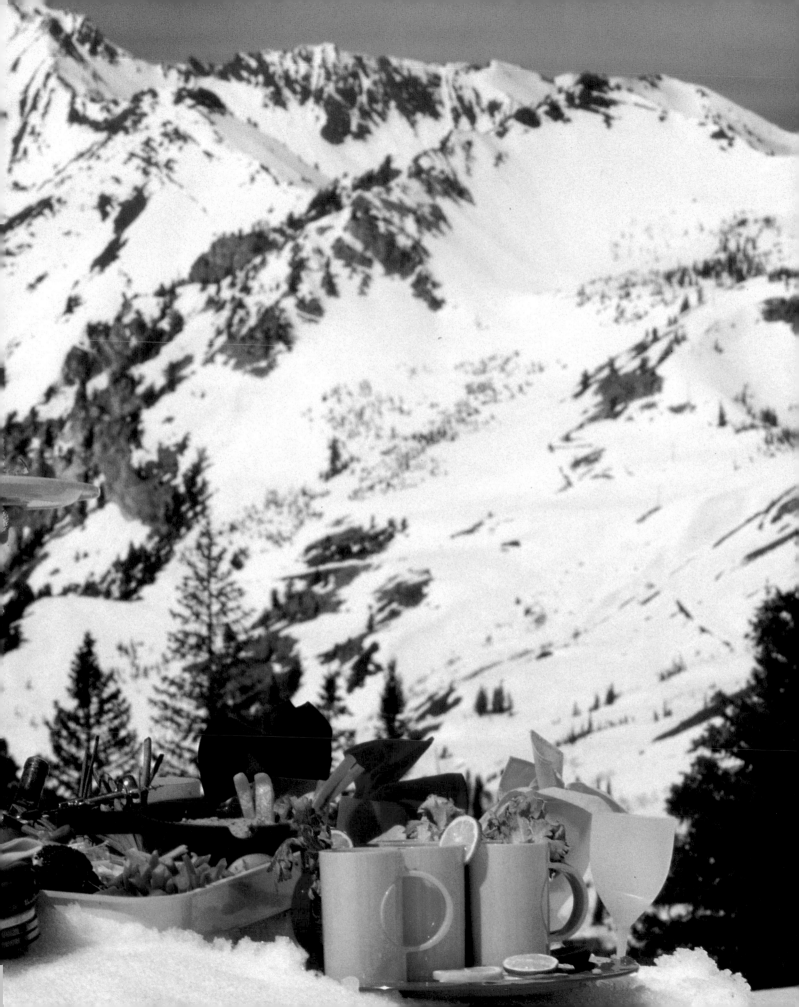

Cape Cod

Our old-fashioned New England clambake was both a magazine production and a local event. I staged it for *Ladies' Home Journal* as an editorial feature that I wrote, styled, and produced outside my home on Cape Cod. Preparing food to feed thirty people and photographing the clambake became a huge, multicoordinated effort. With the steaming pit, the seafood cooking, and the array of colorful props, it was a visual feast as well. My job was to make it look as appealing and natural as possible.

We shot the feature in late September, a time of year when the weather is cool and uncertain, but the day of the shoot turned out to be beautiful and sunny, and some of us even went swimming.

While the rocks in the pit were heating (we fired them up early that morning), I picked up lobsters and clams from a local purveyor, and potatoes and corn at a farm stand. I had made the clam chowder the night before, along with the desserts. Tamara Schneider, the art director from the magazine, was on the beach to direct the shoot. All necessary permits, including those from the local fire department and town hall, had been obtained.

The prop stylist did a great job, shipping props from New York City and filling in with additional accessories from my house. The night before the shoot, we spread everything out on several large tables and planned our strategy, creating a schedule for the next day, which we followed from 6:30 A.M. until the delectable feast was over.

Photographer J. Barry O'Rourke not only aided in "schlepping" what seemed like thousands of pounds of seaweed and organized the digging of the pit at 6:30 A.M., he also shot the scene rapidly, giving form and shape to the food and making the people there look like a natural part of the setting.

"You have to deal with available light when shooting on location," Barry says, "and find a way to backlight the food; otherwise, the picture looks flat. John knew exactly where the sun moved across the beach, which made the shoot much simpler. I'm always careful not to shoot between 10:30 A.M. and 2:30 P.M., as the light isn't directional then and colors won't be saturated. An outside shoot is best scheduled between 5:00 and 10:00 A.M. or after 3:00 P.M., the time we ended up shooting the clambake.

"I used a 35mm camera and Kodachrome film, which allowed me to work faster and get more shots than a larger format would. In the time it would've taken to set up an 8×10 image, I was able to do twelve shots. I took a lot of side and detail shots because you never know what will appeal to an editor. I don't use Polaroids outside—they're only consistent in the studio. The main reason this shoot went like clockwork was that we had thought it out and knew how we wanted to present the story."

J. BARRY O'ROURKE

A graduate of the Art Center College of Design in California, in 1960 Barry opened his first studio in Los Angeles. For the past twenty-four years he has been a generalist in New York City, shooting for most major magazines, including **Bon Appétit** *and* **Ladies' Home Journal,** *as well as doing advertising work for such clients as General Foods. Barry was recently president of the Advertising Photographers of America, and is president and part owner of the Stock Market Photo Agency.*

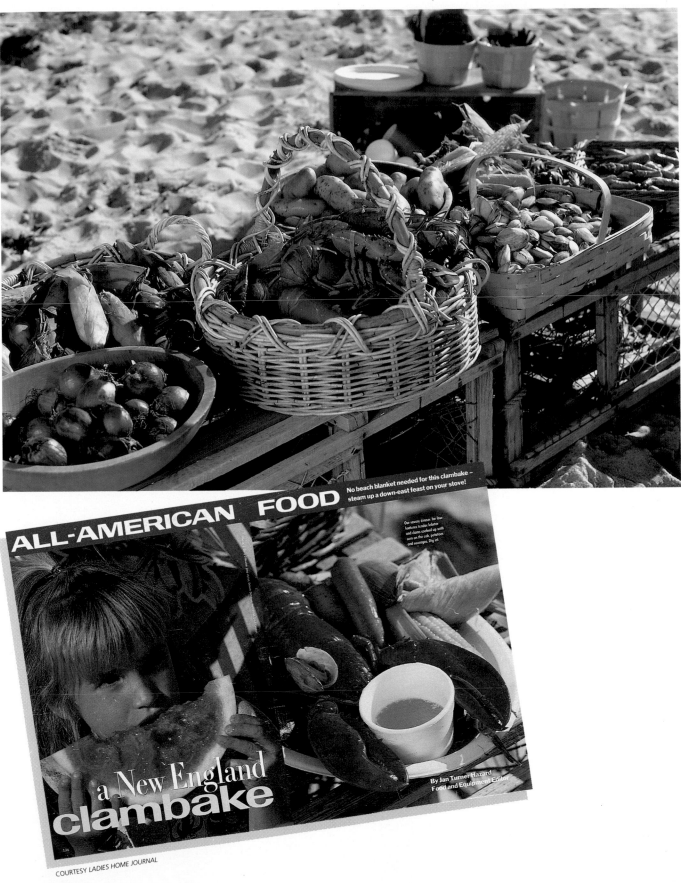

ALL-AMERICAN FOOD

No beach blanket needed for this clambake – steam up a down-east feast on your stove!

Our savory dinner for four features tender lobster and clams cooked up with corn on the cob, potatoes and sausages. Dig in!

a New England clambake

By Jan Turner Hazard
Food and Equipment Editor

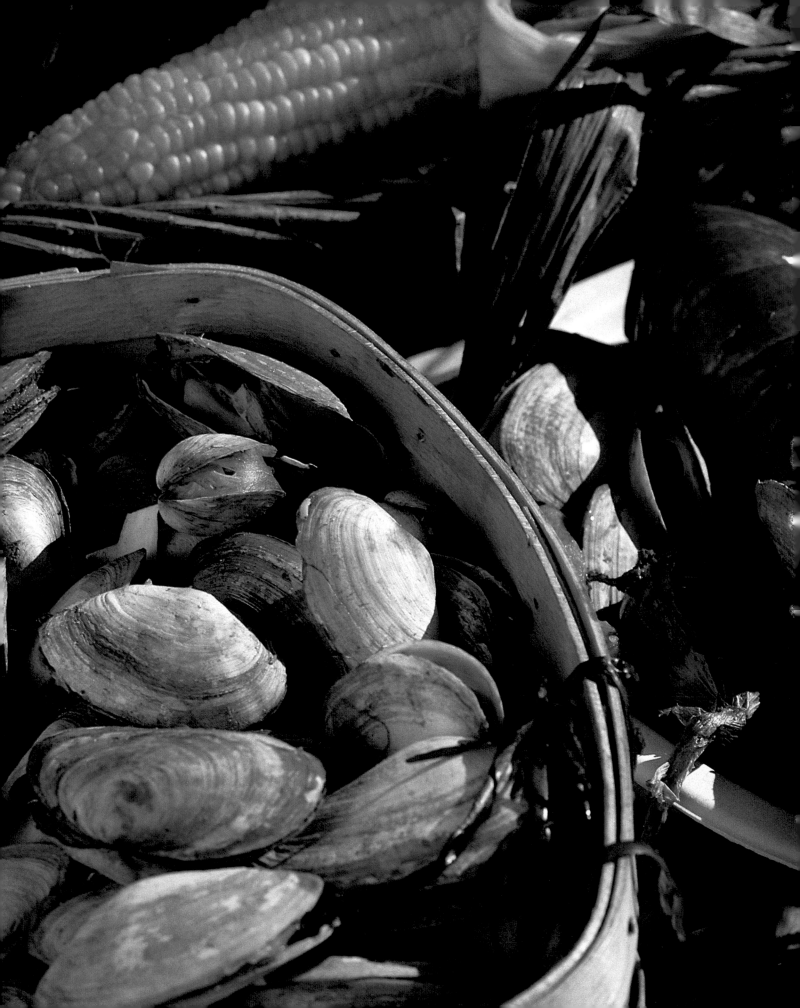

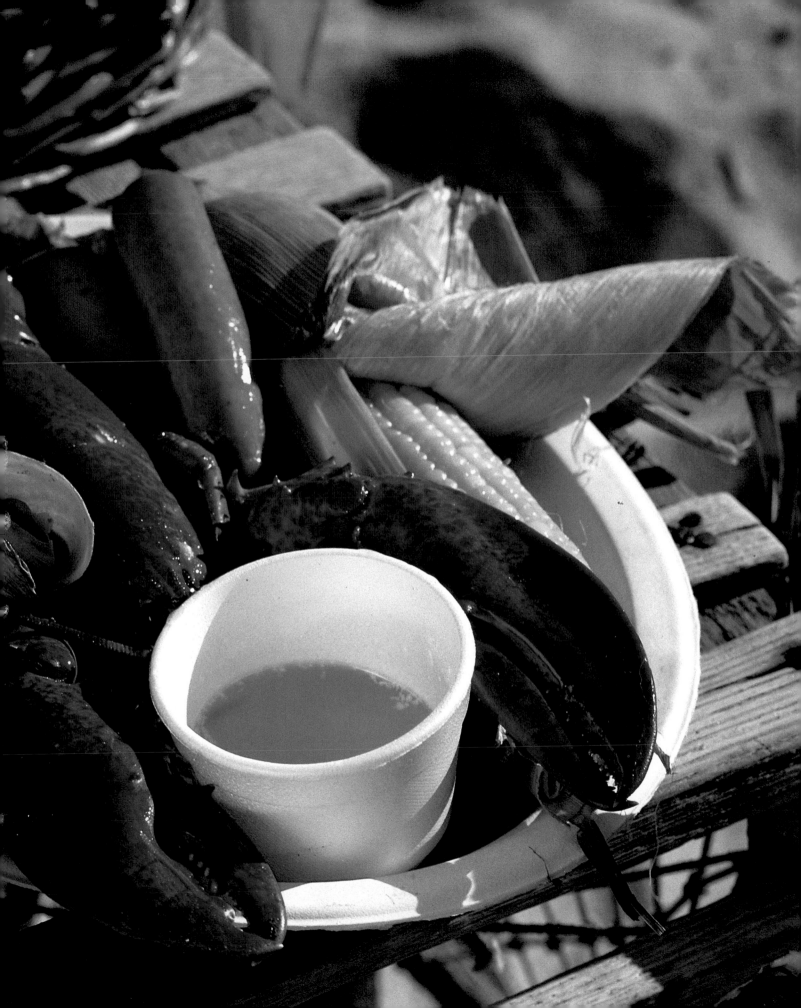

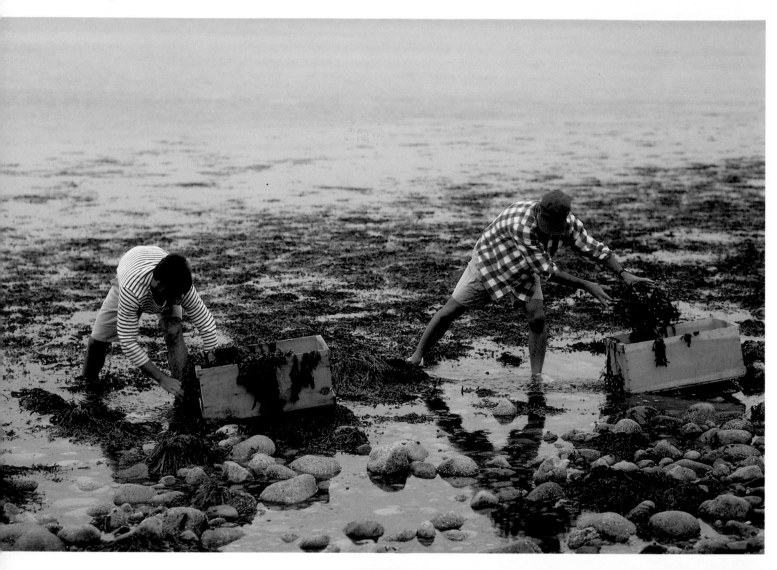

A clambake takes a lot of seaweed. We gathered it right out of the water, then piled it high over heated rocks. Next, lobsters and corn were placed on top of the seaweed. This layering of natural elements created the steam that cooked and flavored the food.

Hot dogs, clams, and onions were tied in cheesecloth. Everyone helped. The corn was delicious—I sat down and had an ear myself.

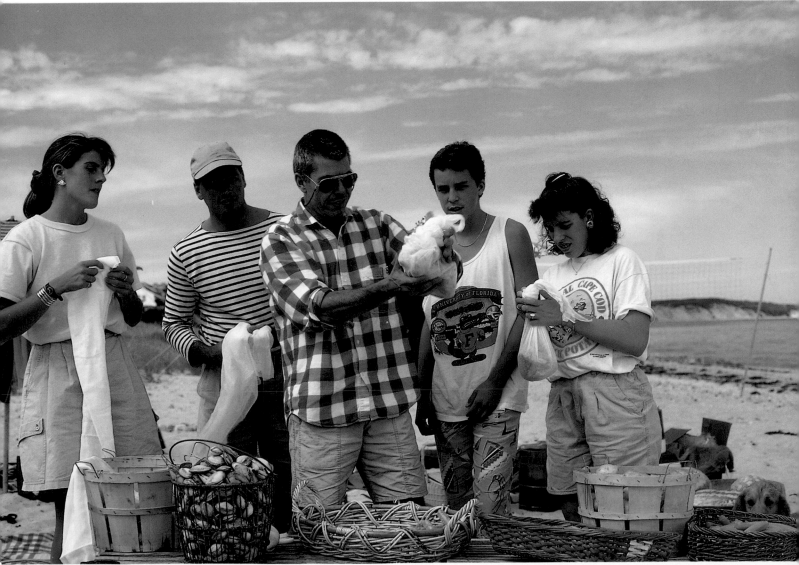

Kari Haavisto

Kari Haavisto was born in Helsinki, Finland, where he worked as a photographer for twenty years before coming to New York City four years ago. His precise, crystalline work has appeared in New York Magazine, Family Circle, *and* New Choices *magazines.*

On another assignment for *New Choices* magazine, photographer Kari Haavisto, art director Sara Giovanitti, Kari's assistant, and I set up a shoot at a private home in Los Angeles. Our goal was to do a lifestyle feature that included food, an integral part of Southern California culture. The magazine's editor wanted to document a dinner party thrown by the couple who lived there. I was given access to their dishes, serving bowls, glasses, and other tableware, and I filled in with props purchased in the area, including flowers and lots of fresh produce.

Kari is truly an artist with a camera, and his specialty is interiors and food design. We both prefer a natural look, choosing not to fake the food we photograph too much. He shoots close to the food, looking down on it and playing with the round shapes of plates to frame their contents. I try to work with him by providing such translucent produce as lemon wedges or a piece of a lettuce leaf to create an illusion of radiance. We both think it

helps bring the viewer inside a picture.

"The problem with shooting food," says Kari, "is being able to produce enough pictures when the light is optimal. I try to let light play a very important role in a picture, but when the sun is your main source, you can't change its direction—it follows its own course.

"I try always to include the light source in my shots," he continues, "and in the closeup of the black-bean soup (right), a reflection of the sky and clouds in the soup spoon is an interesting detail. Be careful, though, not to overdo things like this. And, in this shot, a bouncing light made strong highlights on the bread.

"One more thing," he adds, "I don't use Polaroids. I think they overkill a shoot. Instead, I do many variations of an image. My shooting is a process, rather than trying to create one perfect shot. If I did that, there would be no room for accidents, for the creative process itself. Photographing food must be a spontaneous statement."

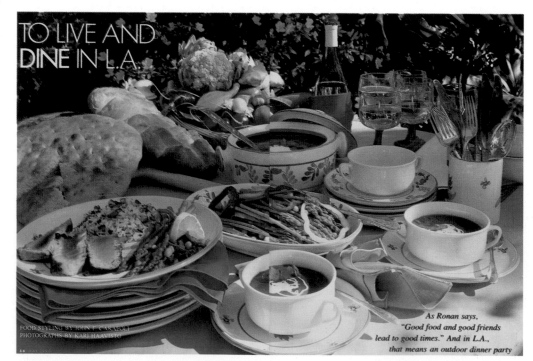

TO LIVE AND DINE IN L.A.

FOOD STYLING BY JOHN F. CARAFOLI
PHOTOGRAPHS BY KARI HAAVISTO

As Ronan says,
*"Good food and good friends
lead to good times." And in L.A.,
that means an outdoor dinner party*

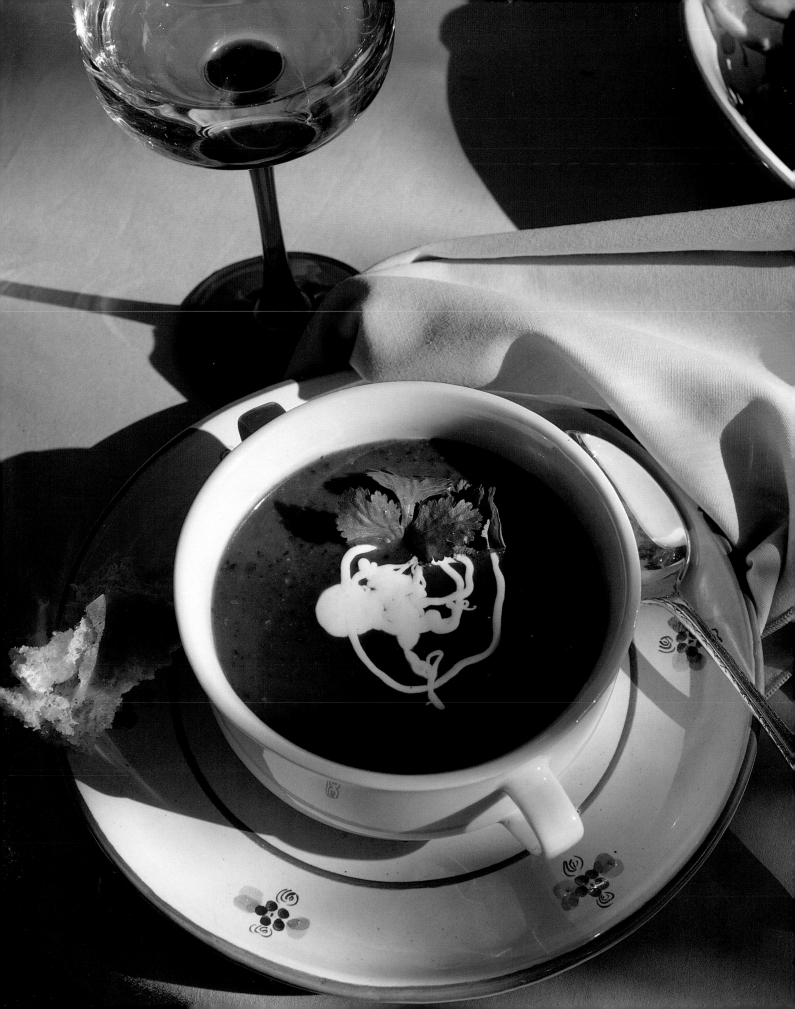

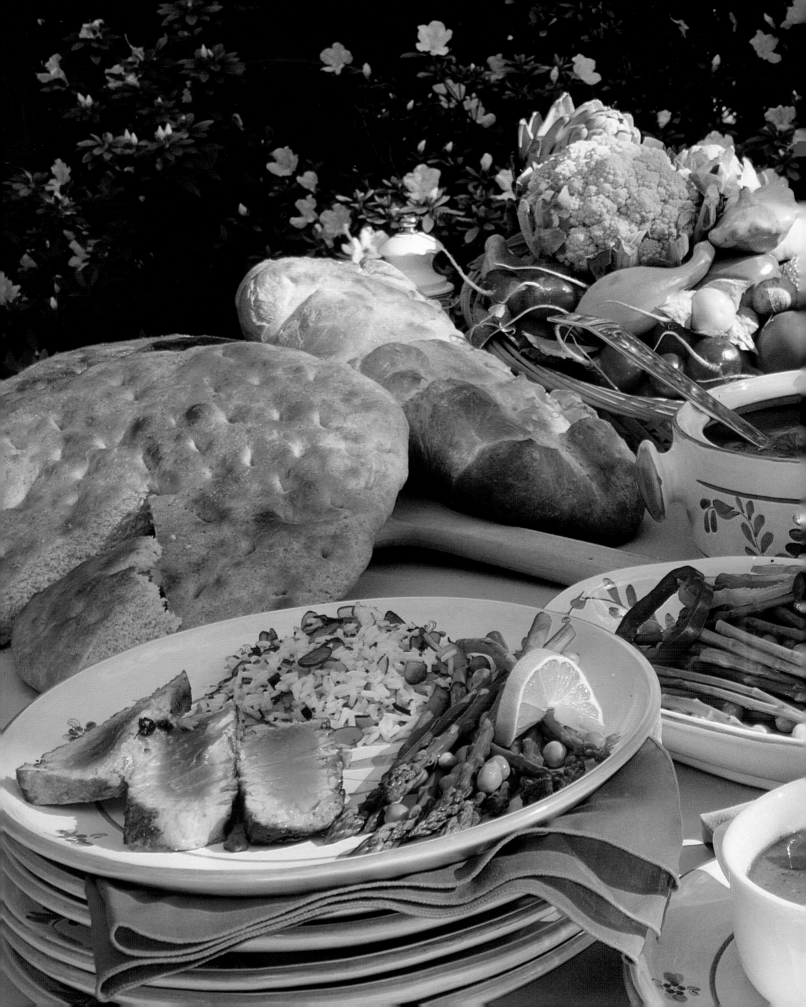

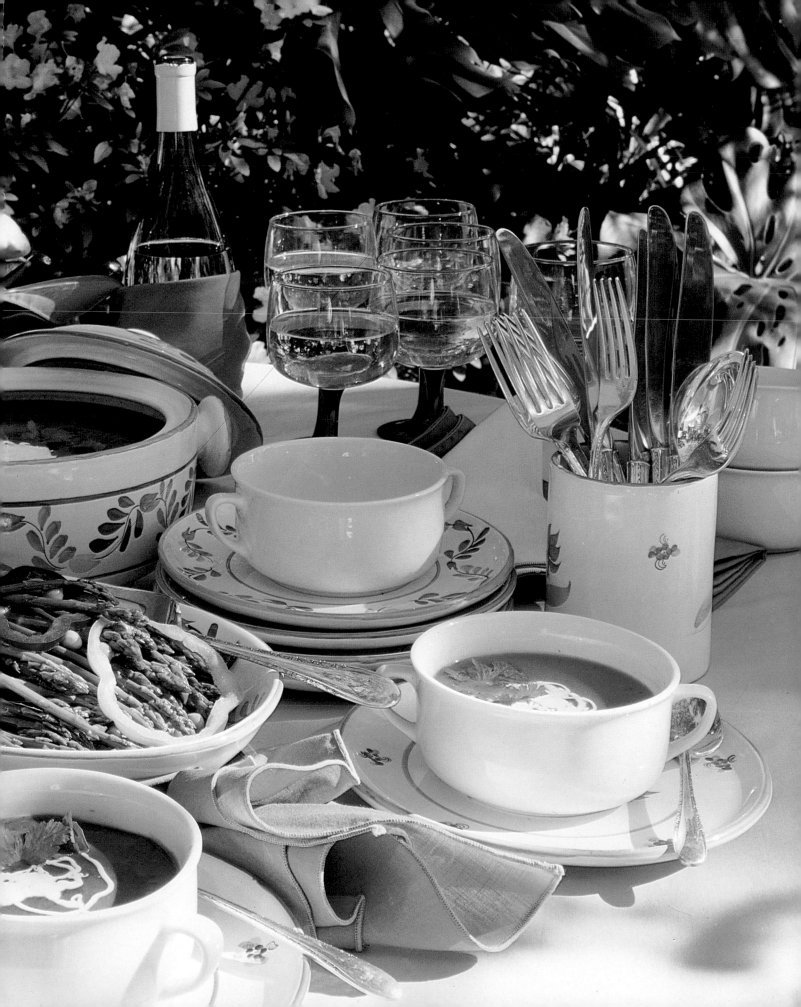

Los Angeles

Outside in their backyard, I arranged the dishes on a table set up for the shoot. A few hours later (below), you can see how the mid-afternoon sun has moved across the table, casting dramatic shadows on its way to setting over the canyon. Sara and I styled a centerpiece of fresh vegetables for the shot—it seemed appropriate for California. When Kari began shooting, I held a fork in place for one of the photographs (below, right). Notice how close to the table he works, hovering over the food.

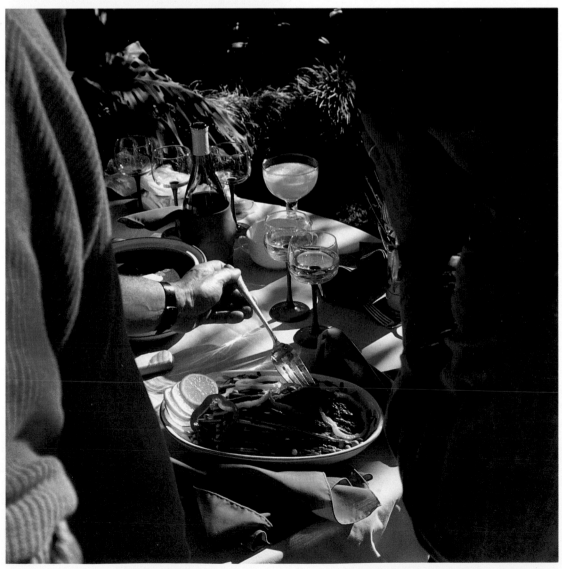

It is a beautiful setting, the climate is delightful, and anything you do in the Caribbean takes twice as long. Moving around on a boat—for example, transporting equipment via dinghy from your sailboat to shore through the surf—can sometimes jeopardize what you're trying to accomplish. Styling food on the ocean isn't like walking across a studio to pick up a pair of tweezers—the sun can be brutal on people, and the food wilts in seconds. All typical technical problems are magnified but—oh, the results! See for yourself.

Photographer Jim Raycroft hired me to style a seven-day shoot for a brochure promoting the Sea Cloud, a new 85-foot ketch in the Virgin Islands' charter fleet. Eleven of us—a hair and makeup stylist, wardrobe stylist, three models, an art director, two fashion coordinators, a photography assistant, Jim, and I (not including the crew)—worked together on this location shoot, planning our schedule around the sun's angles. Everyone had accommodations aboard the boat. Everybody's creative input was wonderful and played a large role in the themes and locales shown in the brochure. Someone would get an idea, and we would all work to put it together—the best kind of collaboration.

I did all the propping and food-prep work, and even modeled. A shot of me pouring champagne for brunch wound up on the cover of *Yachting* magazine. But mainly, I focused on the food. It was already on board when I arrived. I prepared it in the ship's galley. Working around the chef's planned menus, I used them to create a brunch and picnic on the beach.

JIM RAYCROFT

A graduate of the New England School of Photography, Jim Raycroft is a location photographer who specializes in aerial and nautical photography. Cited by **Yachting** *magazine as one of the world's top marine photographers,* **his Caribbean shots of yachts and sailboats have appeared on the covers of almost every national yachting magazine.**

PHOTO © ESPEDITO RIVERA

You slowly break into a smile as, eyes still closed, you remember where you are. You can't even recall feeling so totally, deliciously relaxed.

What to do today? Maybe a little snorkeling, or windsurfing. Or maybe sail the Sunfish or climb in the Zodiak and head off to some unspoiled beach for a picnic. Maybe. Or, maybe just stretch out on deck and catch some rays.

But first, you'll join your friends on deck for breakfast and think how even the coffee tastes richer surrounded by fresh salt air, warm sunshine, and soft music.

Sea Cloud's crew of four is there to indulge you, whether it means a short course in sailing or a full course dinner in the salon. They're aware of your preferences, right down to your favorite vintage wines and liqueurs. You'll enjoy what you like, when you like it.

There's no question that everyone's having the vacation of their lives. Sea Cloud is, after all, an 85-ft. ketch with four guest staterooms — each with double and single berths, its own private head and shower and a glorious ocean view. And when you need some space, there's more than enough of it — for fun, for privacy, for everyone.

Then you think ahead to the best part of the day — the part where you stretch out on deck and sip champagne as the sun slips beneath the water's edge. Later, a meal you've spent the entire day looking forward to. Then a chance to share the evening — and the videotapes you made during the day.

It's a brand new day in paradise. In your berth aboard Sea Cloud, you lie still, stretching slowly, softly, nearly ready to open your eyes and greet the morning. But you wait just another minute, as though afraid to wake from a beautiful dream.

Snuggled in your berth
aboard **Sea Cloud**, you wake

Sea Cloud

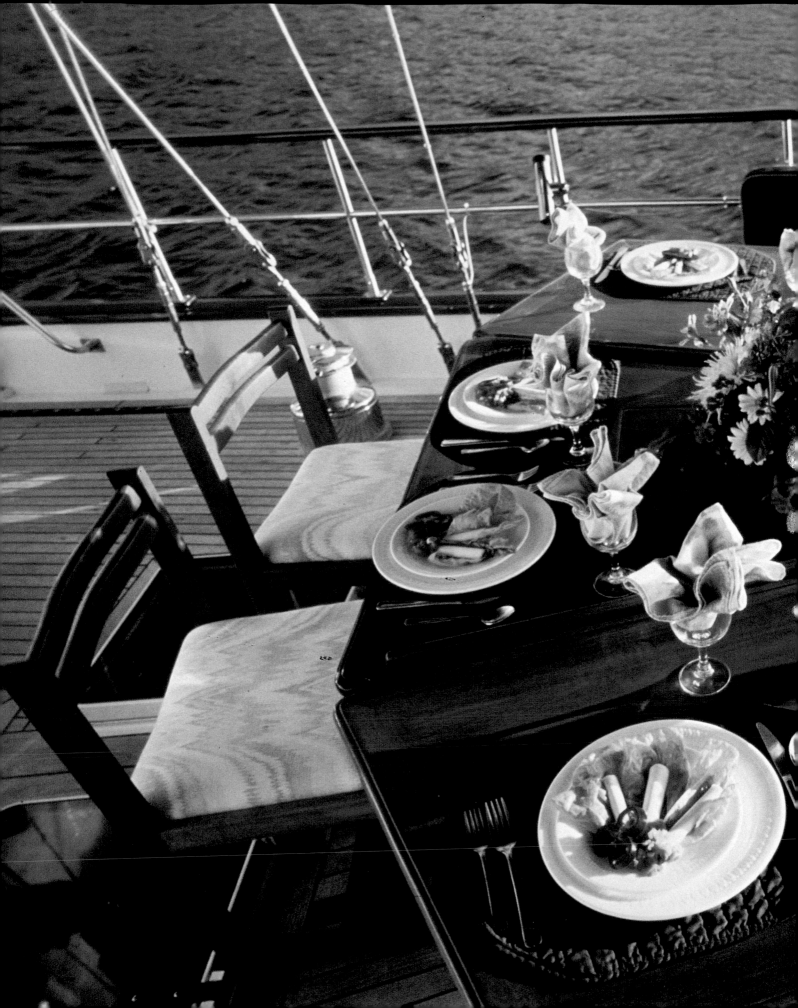

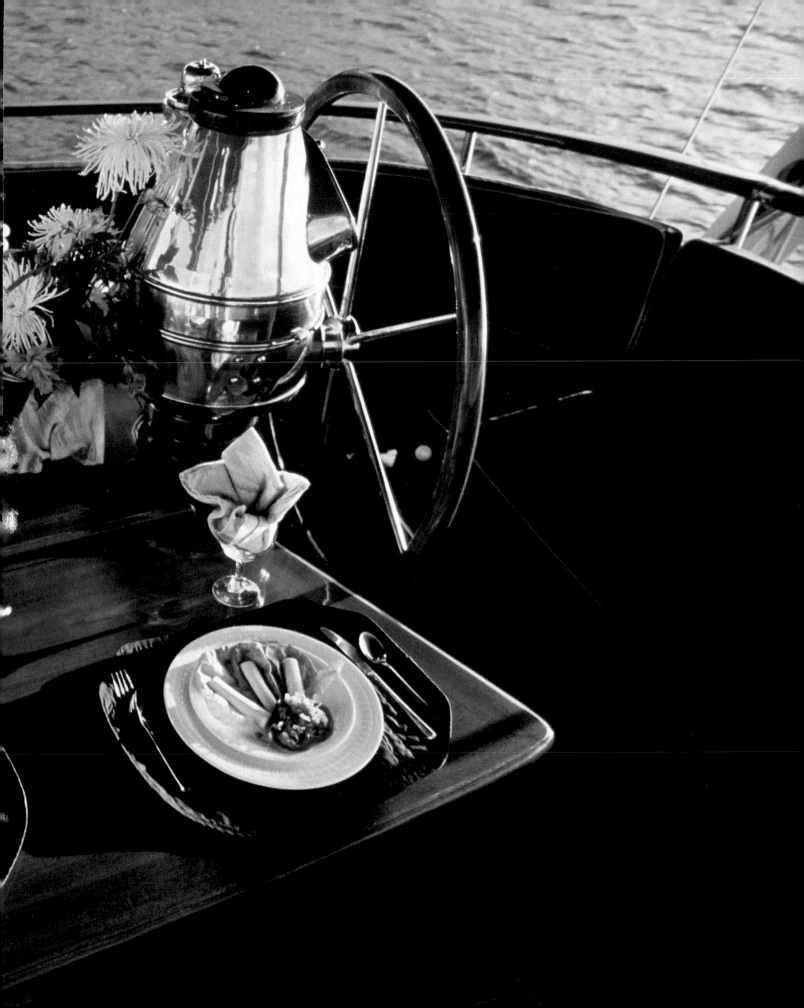

The Caribbean

Everyone working on this shoot had a great time. One day we set up a picnic on the beach and shot the boat in the background (below). Our "table" was made out of twigs that I found on the beach.

The most elegant shots we produced were on deck around a casual brunch (right). Here the food was used to create an ambiance for the socializing on board, something the client wanted to show.

Pictured here with me are art director Bill Hall (center) and photographer Jim Raycroft (right).

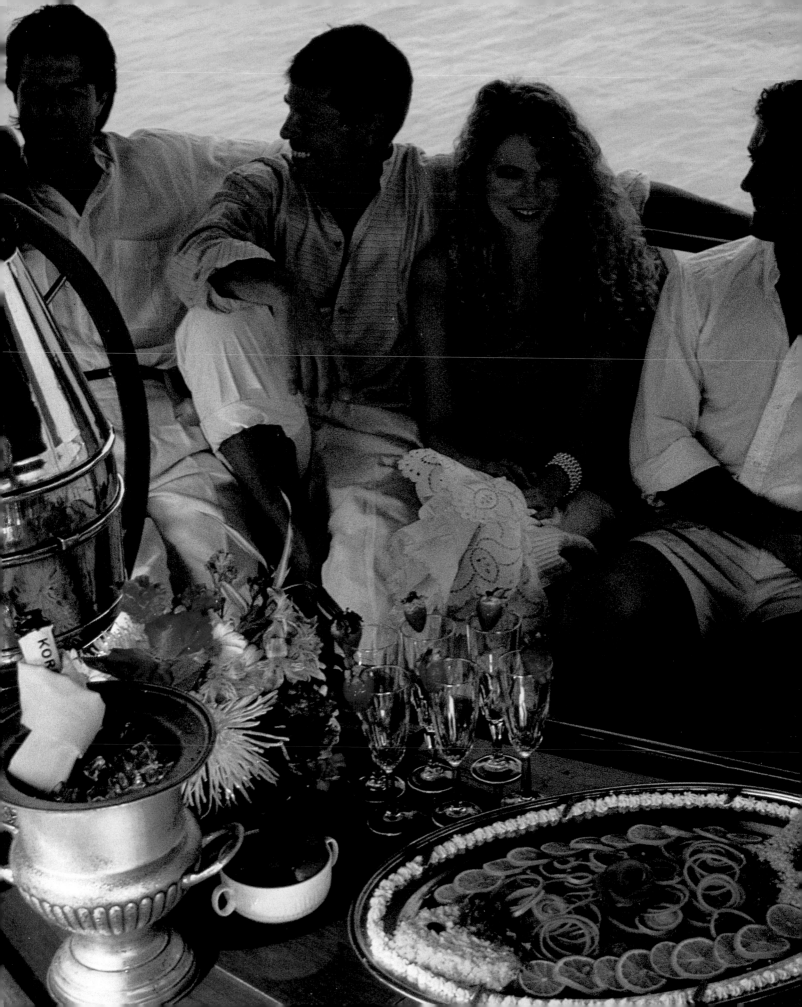

Pepperidge Farm

Jim Raycroft also hired me to style the food for a Pepperidge Farm brochure. The client supplied me with their open-faced croissant pastries, the products they were featuring. I went through boxes and boxes of their pastries, selecting ones that had the correct color and shape for the shoot. All the food was prepared at the studio, even the artificial ice cream used in one of the shots.

The client's concept was "great eating" and all of the pictures in the brochure included Charlie Welch, longtime spokesman for Pepperidge Farm, as well as the product itself. The cover shot (below) showed Charlie holding an unfilled open-faced croissant. The shots were also intended for publication in food-industry trade magazines.

Timing the food preparation was critical, as there were many shots scheduled to be prepped and coordinated. The client let me go wild and garnish the open-faced croissants with tantalizing options to create appetizers, full sandwiches, and desserts. Sometimes I was putting the finishing touches on the food right before Jim made the final shot.

Jim lit the set with a softbox overhead and some fill on the side, creating a soft directional light. "Respecting the talent (models) is always essential," he says. "In this case we were dealing with a real pro, and we were doing as many as four shots a day. We took regular breaks and timed the food preparation with John."

"This new Open Face Croissant Pastry comes in handiah than a hanky salesman at a June weddin'."

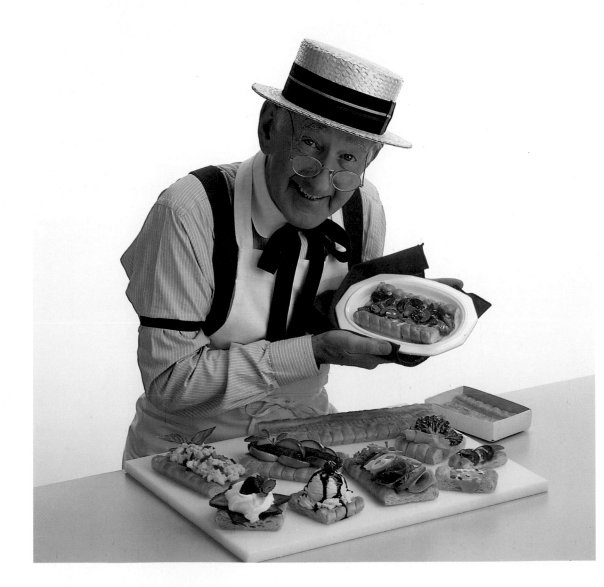

Pepperidge Farm

I made about thirty-five pastries, using such diverse main-course toppings as chicken, cashews, and pea pods, as well as a pizza shell formed from the croissant.

The dessert croissants were mainly created from instant puddings and artificial ice cream, which were embellished with whipped cream, syrups, and fruits.

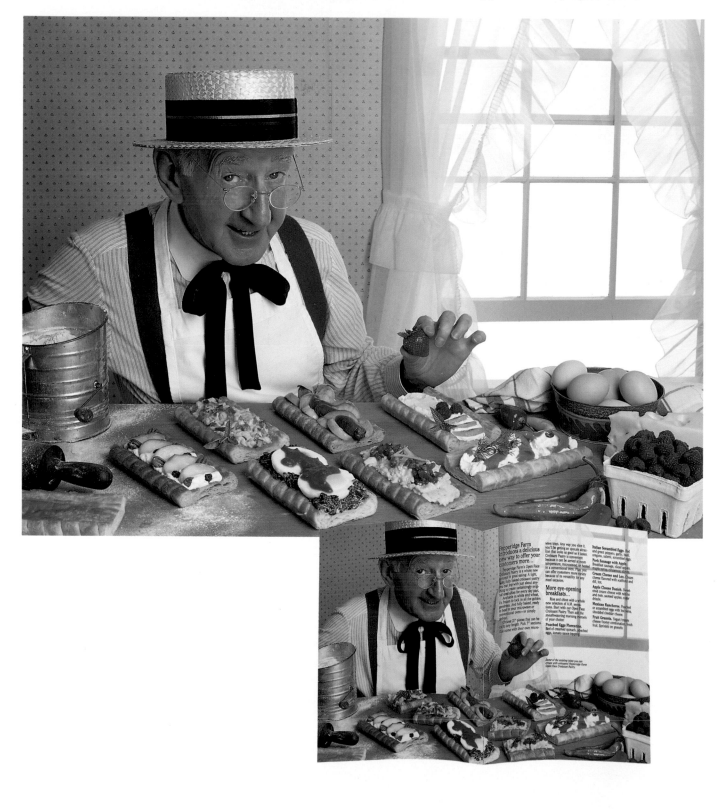

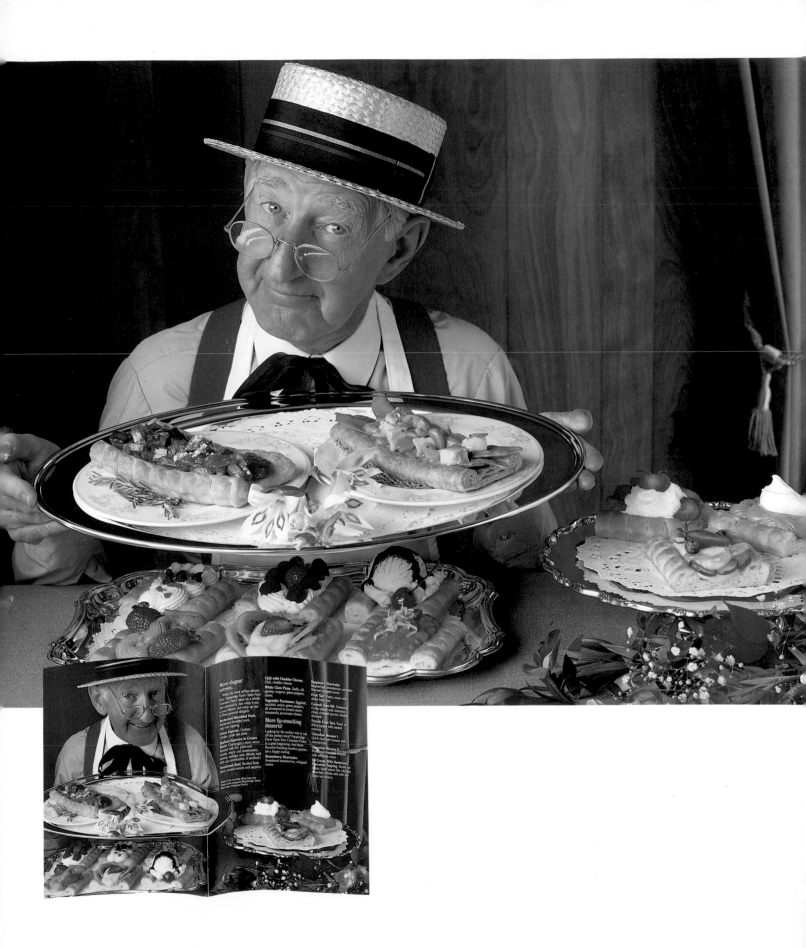

TECHNIQUES FOR SHOOTING ON LOCATION AND WITH PEOPLE

FOOD ON LOCATION

If you are unfamiliar with the area, call ahead and hire an assistant—in this case, someone who knows the area and good places to shop for food, and someone who can do some of the food shopping if necessary. Have a list of the groceries you will need before you arrive there, and ask your assistant to meet you when you arrive. I've found that this saves me a lot of time.

Know where you will be prepping the food and what facilities will be available to you. The more knowledge you have about the area and location, the less problems you will encounter.

Work with the photographer and art director to develop a shooting schedule, and plan everything that is supposed to happen while you are on location. Schedule which food should be prepped first, when foods are to be shot, and how you envision the time the different food shots will take. Share your ideas with the photographer—he or she will have important input.

Think of how you'll be presenting the food, but if the shoot doesn't go the way you envision it, be flexible, spontaneous, and above all, be creative with what you've got on hand.

Do some physical exercise the morning before the shoot or afterwards. Find places to relax—meditate, even have a message.

Keep your energy up.

WORKING WITH PEOPLE

When people are included in your photographs, it is always important to make them feel relaxed and comfortable, whether or not they are professionals. Photographers and stylists have different ways of doing this. Usually, it isn't the stylists job to make the "talent" feel at ease, but stylists can help by creating positive energy on the set.

George Carol Whipple, III, says, "My brain is thinking about the picture while I watch everything going on, from the lighting to the expressions on the people's faces. My mouth says anything, and I mean anything, that it takes for me to get the picture! People just start laughing, and that makes for good photography."

Children

Carl Scarbrough, a photographer and manager of Carol Kaplan's studio, talks about their techniques for working with children. "We talk about things that children find interesting and keep the environment relaxed and comfortable, even upbeat and fun. Mostly, we just talk to them. Babies under three years old need a different kind of attention. Usually, the children are the ones who dictate the tempo of the shoot and how we work with them. Giving them lots of breaks is a must. We don't expect children between the ages of four and seven to last more than an hour on the set."

Nonprofessionals

Jim Raycroft says, "Real people take a lot more care because they don't know how to perform in front of the camera. Your expectations for them have to be different than with professional talent. I have to be clear and gentle to help them be self-confident. I prep them, direct them, and literally get out there and *show* them what has to be done, but in a caring, confidence-building way."

Tips for Food Stylists

Keep it simple. Don't overstyle the food. If you make it look too perfect, it won't look appetizing or real.

ONE SECRET to successful food styling is good preparation. Before you arrive at a photographer's studio, you should have worked out the logistics for the food you are styling. Then you'll feel confident and be able to handle the unexpected as it arises. It is important that you convey this confidence to the photographer and other people working on the shoot. ☝ The first step in preparation is to understand the client's needs. Whether the shoot is for print advertising, editorial publication, packaging, or television makes a big difference in what is expected of you. Editorial work is much looser than advertising or packaging. Most advertisers have to adhere to very definite and restrictive guidelines. If, for example, you were styling a television commercial, you would typically need to buy more food products than for a still-photography shoot, because there are a lot more "takes" in televsion work. All media have different standards and criteria. Be very clear about what is expected of you when you take a job. ☝ Discuss with the photographer how he or she wants to approach the shoot. Some foods are extremely perishable—indicate such potential problems to the photographer. Stress that you both must work fast to ensure the food's freshness in its most natural state. Schedule a time for getting the food on the set, and find out what the photographer's timetable is. The bottom line is to coordinate things so that you can work closely with everyone in the studio. Although you and the photographer may not always agree, food photography is a team effort, so be open and receptive to suggestions. ☝

Buy only the freshest produce and food products, and buy more than you think you will use. The night before a shoot, make an outline of your responsibilities and how you're going to fulfill them. Go over all of the shots you'll be working on the next day. Visualize and work out on paper how you want each shot to look and what has to be done to accomplish your goal. Organize all the equipment you will be bringing to the studio.

When you arrive there, organize the kitchen or the area for food preparation, and feel comfortable in it. This is your working space. When preparing the food, keep ahead of the photographer. Don't make people on the set wait for you. Be aware of the food at all times. If you are doing a large spread of food, first prepare the items that will last longest on the set. Don't oil or make glisten foods that aren't naturally shiny. If you do, the food and the final photograph will look staged. Keep the food looking natural!

Besides preparing and designing the food, you should have some knowledge of photography and lighting. The best results come when the photographer, the client, the art director, and the stylist work as a team. As you look at the food you're preparing, think about camera angles and how the food will look its best. You might ask the photographer to light it a certain way—for example, to backlight a lemon or a piece of lettuce to create a translucent quality. Often the right lighting makes or breaks a photograph, so you should be aware of how the food is being lit.

While the photographer, art director, and client are discussing how the Polaroids look, the food on the set may be losing its edge. Do your best to convey this to the photographer, using tact and patience. Replace food when necessary. It isn't always apparent to everyone when food starts losing its natural qualities. Stay on top of how it looks (a good photographer will also notice).

You must take total responsibility for the visual appeal of the food you are preparing. It is very important that you, and you alone, handle the food. Make this clear in a diplomatic way to everyone at the shoot. In the end, you are responsible if the food doesn't look good.

Emotions sometimes run high in a studio. There can be a lot of tension, and it is best to be aware of this when it happens. If I am shooting for more then a day or two, or if I am working on location, I find that doing physical exercise the morning before the shoot or at the end of the work day really helps center me—it releases tension. When you're working on a longterm project, find places to relax, do yoga, or even have a massage. It is important to keep your energy up. Long photo shoots are extremely demanding.

MARKETING YOUR TALENT

The business of food styling is not for the faint of heart. It takes total involvement, which means plenty of energy, a wild and spontaneous excitement about food—and patience, patience, and more patience. *Don't get discouraged!* Be persistent, and know that you have a marketable talent.

When most people think of food stylists, they think of home economists. Today a whole new group of stylists are coming into the field, from culinary chefs to designers. Whatever your background, if you're equipped with a little bit of savvy, the first step is to put together a visual portfolio of your work to show prospective clients. Your portfolio should be well organized and your presentation slick. The goal is to show a variety of food shots and exhibit how you have met each challenge.

For portfolios geared to editorial assignments, more is better. You might want to include a complex spread of food, or a tight closeup of a hamburg or a hot dog. When shooting to build an editorial portfolio for food, include props in your shots if you like. If that kind of styling isn't your forte, don't ruin a shot with inappropriate objects; just have someone else style the set.

A portfolio for advertising work should be more concise. For inspiration, look at the food ads in newspapers and magazines: for example, shots of bacon and eggs (they are a challenge) or orange juice. Try showing your photographs of ice cream, poultry, meat, seafood, or shellfish. You might shoot, for example, a display of a whole raw fish with opened oysters and a variety of delectable produce and potted herbs. Be creative, but at the same time, develop a theme for your work and be clear about what you're trying to say. Advertising clients look for consistency in a portfolio.

Starting out, it can be a good idea to work with another food stylist, someone who can show you the ropes. Be an assistant, an apprentice—be willing to do the dishes and the dirty work to learn.

You could also try working with a photographer who is also trying to break into the food industry. He or she may be willing to accept your input and talent in exchange for chromes for your portfolio. And, if the photographer pitches and gets a job based on your work together, it is likely that you'll be hired for that assignment, too. Find a photographer with whom you are sympatico, and get as many samples of your work together as you can. As Boston photographer Jack Richmond says, breaking into this business is "like dancing—the more you know your steps and dance together, the better you will get."

When I started writing about food and creating recipes for *The Boston Globe*, I hired photographers, and they in turn began to hire me when they needed someone to style food. Getting a "hook" like this—writing about food for a newspaper—was a great approach. Do something similiar, and then be as versatile as possible—for example, write a food column for a local paper or a newsletter. Get as much attention as you can for your work with food.

Packaging is a large part of marketing. It is important for you to have a visual identity, or logo, that your client base recognizes as your trademark. It should appear on your stationery and all promotional materials you send out. If you cannot design one yourself, hire a graphic designer to help you out.

The best way to get work styling food is through direct contact with photographers, agencies, or designers, and by periodically sending out promotional mailers, and then following them up with phone calls. (Several times I've had a mailer land on an art director's desk and then be passed on to someone else, a food editor of a magazine or another art director, who calls me with an assignment.) My first mailer was relatively inexpensive and went out in three parts. The first was a card that simply said "Taste," with a little blurb about what it means. Three days later, the second mailer followed, this one with the word "Style."

Style!
Food concepts that have imagination, creativity and flair.

Finally, a week later the third went out, printed with my last name, "Carafoli," and another short blurb: "A total package for photography, food presentation and presentation with taste and style." When I followed up the mailers with phone calls to the recipients, everyone knew who I was.

I try to do new mailers each year, showing as many different situations as possible. My latest card (middle, left) shows three shots: one editorial picture of rolled, stuffed cabbage with tomato sauce; one advertising shot showing a cross section of grilled picnic meats; and an advertising shot of a soft-serve ice-cream drink with a creamy, foaming, curled topping. This promotion also appeared as an advertisement in *The Workbook* (Los Angeles: Scott and Daughters Publishing, 1992), a sourcebook of photographers and graphic artists used by art directors and designers. If your budget affords the expense of advertising in a sourcebook, do it! The exposure is great.

Keep your name out there—staying current is important. Market yourself by mailing promos and calling art directors and food editors. Call them again. Then get on the phone and call magazines. Hustle! Create excitement about your work. If you put your energy out there, you'll be surprised at the response. The mistake that many food stylists make is not being persistent.

Mailers work only if you follow them up with phone calls to make appointments for showing your portfolio. And you have to make appointments before calling on photographers. Always try to have a personal interview with anyone—photographers, art directors, editors—willing to see your portfolio. They are more likely to remember your work if they can associate it with a personality. During the interview, show confidence and knowledge about what you are doing. Let your potential client know that you can handle any problems presented to you.

Keep your antennae out! One day I walked into a studio where they were shooting furniture for a major catalog. The furniture arrangement was static, and I had some ideas about adding motion via food. I asked the art director, "Hey, don't you guys want some food in those shots?" My concept excited the art director, who called me a few days later. Because the furniture was Scandinavian in design, I splashed some Aqua Vitae into a glass for one shot and styled another with a huge salmon that lay across the bottom of a double-page spread of the furniture.

A tip about pitching a client: If he or she is looking for a specific kind of food shot, then narrow your portfolio down until it pertains to that type of food. For example, if someone wants to advertise a meat product, bring in a portfolio of your best grill-marked hamburgers, hot dogs, steaks, and chops. Also, it is a good idea to be able to show how appealing you can make a moderate amount of food. I recently did a job for *Weight Watcher's* magazine where I had to weigh the food I prepared. Ground Round is another client of mine with strict specifications about weighing food; they want what comes out of their kitchens to look like what is presented on the menu.

Put aside a day for calling photographers, art directors, and food editors. They usually won't return your calls unless they are working on projects that require stylists, so don't take it personally if you don't hear from them. Find out who their clients are, and keep your mailers and calls flowing. When you finally reach them, ask if you can come in and show them your book.

Most of my jobs come through photographers. However, at magazines it is usually the art director and food editor who assemble the entire team for a shoot. As for money, well, you may start out only earning $20,000 a year, but the stakes in advertising run high, and you could make as much as $125,000, depending on your client base. Magazine editorial work currently pays about four times what newspapers pay food stylists. I bill for overtime.

Above all, if food styling is what you really want to do, be faithful to your dream and stay focused. Things can go wrong, and shoots occasionally have to be redone. Be philosophical, and view those experiences as an opportunities for self-discipline and personal growth. Don't label them as problems, but rather see them as a part of the process of your own work in food photography and styling.

FOOD DESIGN/STYLING

Carafoli

BOSTON 617 • 888 • 1859 NEW YORK 212 • 532 • 6387

Bacon

Choose the best-looking, unbroken slices, and cook them over low heat in a nonstick pan. Keep the bacon pliable by not over-cooking it. Touch it up on the set by brushing it with a little oil to make it look hot.

Baked or Fried Breaded Chicken

Fill a plastic bag with store-bought breading (seasoned or unseasoned, depending on your client's needs), put raw pieces of chicken inside the bag, and shake it to coat the pieces. If you want the chicken to have a darker, more baked look, spray the coated pieces lightly with a coloring solution used for browning poultry (see page 38). I've found this method of faking the baking process to be very successful, and it saves time. Fish and other meats can also be breaded and "baked" this way.

Bubbles

Dip the end of an eyedropper into a little Photo-Flow (available at photography stores), add a little to your liquid, and work it in to create the desired bubbles. Adding a little egg white also works. Adding soap or detergent puts an iridescent film on the bubbles.

Glass bubbles can be purchased at stores specializing in special effects for photography. Don't use them with wine or transparent drinks because there is a small tip on each bubble to hold it upright, and in clear liquids these tips will show.

Chocolate Candy and Garnishes

To remove scratches from hard chocolate and to clean delicate pieces of chocolate candy, brush the chocolate with a soft sable brush. Before shooting, hold a paint stripper, hair dryer, or similiar heating element over the chocolate for a few seconds to give the chocolate a nice glossy sheen.

To make chocolate shavings, begin by chilling a block of chocolate. Run a vegetable peeler down the side of the chocolate to produce the shavings.

To create curls, place a large piece of Baker's chocolate on a piece of aluminum foil, and let it stand in a warm place (90-100 degrees) or in a gas oven with only the pilot light on until the chocolate is slightly softened. Using a vegetable peeler or a sharp knife, shave the chocolate from the bottom up to make curls. Quick strokes make tight curls; slow strokes make looser curls. Carefully pick them up, one at a time, by inserting a wooden skewer into the center of each, and transfer onto a baking sheet lined with waxed paper. Chill until firm, and arrange them on the dessert.

To make chocolate leaves, melt Baker's chocolate and, using any kind of leaf, paint the chocolate on the leaf with a brush. Keep the stem on the leaf for handling it.

Chocolate Sauce

Chocolate sauce should be made the day before the shoot and allowed to settle. This will clear it of bubbles caused by stirring. This recipe can be doubled or tripled:

1 cup Baker's chocolate

1 cup vegetable oil

In a double boiler, melt the chocolate. Stir in the oil a little at a time. Remove the sauce from the burner, and cover the sauce with a paper towel. Don't use plastic wrap—it will trap moisture in the pot, which will ruin the chocolate.

Cleaning Serving Dishes and Glasses

Wash the dishes in soap and water, then clean them with a good glass cleaner. When carrying dishes to the set, hold the dishes with paper towels or use cotton gloves to prevent fingerprints.

Coffee

Mix a gravy coloring, such as Kitchen Bouquet, with water to simulate coffee. Real coffee contains oils that the camera will pick up on film.

Cooked Sauces and Gravy

If you want a sauce or gravy to appear translucent, thicken it with a little arrowroot mixed with water. For a creamy look, add cornstarch or flour.

Deep-Frying Foods

When using new oil, first deep-fry several pieces of food until they are very brown. For example, if you want to fry potatoes, take a handful, fry them until deep brown, and then discard this first batch. Frying them will add enough residue to the new oil to impart a golden tone to the rest of your fried food.

Grilled Hamburger Patties, Steaks, and Meats

Using lean ground meat, make the hamburger patty slightly larger than the bun—cooked, it should cover the entire bottom of the bun. Cook the burger only to brown it in a nonstick pan sprinkled with salt. The salt will cut down on the spattering. It doesn't matter if the inside isn't cooked. Use a blow torch to cook the edges of the patty. Make sure that the color doesn't become too dark; the patty will photograph darker than it appears. Drain the burger on paper towels until ready to shoot.

Put a padding of paper towels, cut to the size of the patty, beneath the hamburger before placing it on the bun. Make sure the towel doesn't show. It will absorb the meat's juices.

Cook a steak only on one side. Don't overcook it, or it will shrink. Using a blow torch, sear the top and sides of the steak until you've achieved the charred color you want.

To simulate grill marks, sear lines across the top of the steak or hamburger by using a charcoal lighter or thin metal skewers that have been heated over a flame. Keep a few pot holders handy for grabbing the skewers. I sometimes deepen and accent the grill stripes by painting them with Kitchen Bouquet. If the meat appears dry, I coat it lightly with olive oil just before shooting.

Keeping Fruits and Vegetables Fresh

To keep your produce from turning brown, you can coat it with lemon juice or you can use a special browning inhibitor, as I do. I used to use Spud-Nu to bleach out brown spots and keep the produce fresh for several hours. Unfortunately, Spud-Nu has been taken off the market because it contains sulfites. It has been replaced by a product called Produce Freshener, a sulfite-free anti-oxidant available only through institutional food-service distributors. Reformulated anti-oxidants don't work as well as products that previously contained sulfites. Test browning inhibitors before you use them to determine how effective they are for your purposes.

I soak all my vegetables (especially lettuce) in the anti-oxidant as soon as I arrive at the studio. I cut and soak such extremely perishable items as avocados and apples in the same solution. It can also be painted onto produce with a brush.

Salads can be made and, covered with a damp paper towel to keep the vegetables from wilting, put on the set. When you're ready to shoot, remove the towel.

Making Onion Curls for Garnishes

Insert a straight pin into a scallion's white bulb, and pull the pin down the scallion toward the green tips. Repeat this several times, then plunge the whole scallion into cold water, which will cause the strands of the onion to curl.

Techniques for Styling Foods A-Z

Maraschino Cherries

Coat them generously with glycerin just before placing on desserts or ice-cream sundaes. The glycerin will fill in any pit holes or imperfections in the cherries.

Melting Cheese

Use processed cheese because it melts easily and evenly. If a slice of cheese overhangs a hamburger, heat a brush in hot water, then gently go over the area to be melted several times, each time dipping the brush back in the hot water. You may also melt cheese by submerging a slice in hot water or by holding the cheese over steaming water in a tea kettle. Melt the edges of the cheese first, then the corners. If a large surface needs melting, a charcoal starter or heating coil might come in handy. Hold the coil close to the cheese until it melts to satisfaction.

Milk in Cereal

Measure the cereal bowl, and cut a false bottom of white cardboard that can be inserted in the bowl to rest about an inch from top. Lay it in the bowl, and pour a white glue (Elmer's Glue works well) over its surface, then place the cereal on top of it. Drizzle the glue in and around the cereal to simulate milk. Don't use real milk because it is quickly absorbed by cereal.

Perfect Eggs

Always use fresh eggs. Crack an egg into a custard cup, and gently poach it in at least an inch of warm oil over low heat (the oil should cover the yoke). With your finger, move the egg yoke into the right position. These poached eggs will keep all day long in oil. When you're ready to shoot, place them on pieces of thin cardboard that are slightly smaller than the individual eggs. This will enable you to move them without breaking them. When they are on the set, use an eyedropper to drop oil on the yokes to keep them moist.

Repairing Wedges of Cake

Cutting into a cake, the tip of the wedge may crumble a bit. You can repair it. First, attach a piece of light, sturdy paper, the same color as the cake, with Vaseline or clear piping gel (available at bakery supply stores) to the side of the wedge not facing the camera. Then fill in the tip with cake crumbs and pieces to create a perfect-looking wedge, using the Vaseline or gel to hold the crumbs.

Reviving Frozen Cranberries

Soak the cranberries in warm water for at least half an hour, maybe more. Or you can cover a plate with paper towels, arrange the cranberries on the towels, cover the fruit with another towel, and microwave them on high for a few seconds until they are defrosted and plumped up. Note: Because microwave ovens differ, heating times will vary. Experiment with your microwave until you know how much time is right.

Reviving Parsley or Lettuce

Rinse the leaves with warm water, then submerge them in cold water and dry them between towels.

Reviving Tomato Tops

Remove the green tomato tops from the tomatoes. If the tops have dried up, place them in warm water for a half hour to revive. Attach a tomato top to the "hero" tomato with a small pin, making sure the pin isn't exposed to the camera.

Rice and Pasta

Undercook both slightly, then rinse them in cold water. The rice will be fluffy and light. To keep it from sticking, mix in a little oil. Do the same with pasta. Pasta may be cooked the day before the shoot. When it is cool, mix it with light corn syrup, and place it in tightly sealed plastic bags.

Salad Dressing and Dips

To give runny dressings and dips more body, mix a clear gel (available at bakery supply stores) into the dressing or dip.

Sausages

Shape your sausages to the desired length and size while they are cold. They should all have the same dimensions. Place them in pan with little oil, and put it over low heat. Spray or paint them with a solution used for coloring poultry (see page 38). Don't cook the sausages too fast, or their skins will shrink and their color will be uneven. Keep them moving in the pan. This procedure should take less than five minutes.

Selecting Good Seafood

Make sure that the fish's skin is shiny and iridescent, and that its scales are firmly affixed. Its eyes should be bright and clear, and there should be no odor besides the aroma of fresh fish. Brushing a light coat of glycerin onto fresh fish gives it a nice sheen and highlights its freshness.

Sliced Meats

If a slice of red meat is required on the set, create a stand-in first. Then just before shooting, cut the meat and shoot it quickly. Sliced fresh, it will immediately darken to a deep red. Keep the slice moist by brushing the meat with its own blood. You can heighten the color with a little red wine. If the meat looks too raw, brush it with hot water, which will cook it.

Soups

Adding corn syrup to soups creates a glistening sheen on their surfaces. Sometimes this will also prevent surface films from forming.

Toast

Put sliced bread under a broiler, and brown it until it has the desired color. Using a broiler instead of a toaster is better for photography because the broiler gives you more control.

Toppings for Ice-Cream Sundaes

Use only cool or room-temperature sauces on ice cream. Homemade sauces, such as chocolate sauce, should be made the night before and refrigerated. This gives the sauce a chance to set and prevents bubbles. Adding corn syrup to the sauce will give it a nice sheen.

For strawberry or other red fruit toppings, thicken the sauce with red gel (available at bakery supply stores) to keep it from running. Remove actual chunks of fruit from the sauce, and adhere them to the ice cream with toothpicks, making sure that these don't show.

To hold sauces and toppings on ice cream and other desserts, cut a piece of paper towel or tissue paper that is smaller than the area of topping to be poured, and place the paper on the dessert or sundae. It will help hold the topping in place and keep it from running. On the cover of this book, the raspberry sauce on the pear was styled this way.

To create a dollop of cream, use a nondairy product and stir it in the container until you see good lines and have a good swirl. Then lift the dollop out with a small spatula, and place it on top of the dessert.

Resources

PROP AND ACCESSORY RENTALS

BOSTON

Antique Props/Rosalie Davidson
A superb and eclectic selection of unusual tabletop props.
(617) 734-0369

Draw the Line Productions
Unusual conceptual designs and illusionary needs.
Allen Burton
144 Moody Street
Waltham, Massachusetts 02154
(617) 899-7914

Kramer Backdrops
Rich, highly textured, natural-looking, hand-made paper surfaces in sizes to 8.5x12 feet.
Laurie Kramer
535 Albany Street
Boston, Massachusetts 02118
(800) 475-4750

Lighthaus
An amazing array of artifacts, Plexiglas props, shooting surfaces, and unusual accessories.
Ted Jenson
109 Broad Street
Boston, Massachusetts 02110
(617) 426-5643

CALIFORNIA

Pettison Studio Leather
Rents props from the 1830s to the 1930s.
John Pettison
20926 Chatsworth Street
Chatsworth, California 91311
(818) 764-0620

CHICAGO

Prop Room, Inc.
Tabletop props, surfaces, backdrops, furniture, china, and flatware. One of the largest and best collections of props in the Chicago area.

Tom Jakubowski
2343 West St. Paul
Chicago, Illinois 60647
(313) 772-7775

NEW YORK

Freyda Miller
Specializes in the finding and overnight shipment of unusual, out-of-season vegetables, fruits, flowers, plants, and anything that grows. Also provides hard-to-find tabletop accessories.
(310) 474-5034

Newel Art Gallery, Inc.
Furniture and accessories; collection of decorative arts from the Renaiassance to Art Deco.
425 East 53rd Street
New York, New York 10022
(212) 758-1970

The Prop Company
Contemporary tabletop decorative accessories, antiques, ephemera, and furniture rentals.
Maxim Kaplan
111 West 19th Street
New York, New York 10011
(212) 691-7767

Props, Displays, Interiors, Inc.
Stock and custom work for tabletops, surfaces, and such architectural displays as windows, busts, columns, and pedestals.
132 West 19th Street
New York, New York 10011
(212) 620-3840

SPECIAL EFFECTS AND MODELMAKERS

Mark Yurkiw and Company
Modelmakers/Special Effects. A good source for creating just about anything a client can imagine, including artificial fruits and vegetables.
Mark Yurkiw
568 Broadway
New York, New York 10012
(212) 226-6338

Starbuck Studio
General modelmaking. Works in all materials, from acrylics to marble. Rents readymade generic acrylic splashes.
Alan Buckley
162 West 21st Street, Room 2S
New York, New York 10011
(212) 807-7299

Trengrove Studios
Acrylic spills, artificial ice, crystal ice, ice powder, glass bubbles, and special devices for creating smoke and steam.
Tom Trengrove
60 West 22nd Street
New York, New York 10010
(212) 255-2857

STYLISTS' ORGANIZATIONS

A.S.C.
The Association of Stylists and Coordinators
The only New York-based organization for stylists. Call for a directory:
(212) 255-1120

D.M.A.S.
Dallas Association of Makeup Artists and Stylists
A very active, nonprofit organization that publishes a sourcebook and provides networking between members and other professionals in the film, video, and print industries.
P.O. Box 823447
Dallas, Texas 75382-3447
(214) 321-1924

USEFUL SOURCEBOOKS

The New York Theatrical Sourcebook
A complete listing of sources for costumes, props, sets, and lighting.
David Rodger, Publisher
Broadway Press
12 West Thomas Street
P.O. Box 1037
Shelter Island, New York 11964
(516) 749-3266

Chicago Prop Finders' Handbook
A guide to products and services for creative professionals in the Chicago area and the Midwest.
2835 N. Sheffield, Suite 200
Chicago, Illinois 60657
(312) 880-2232

FREE LISTINGS FOR STYLISTS

Photo Source
Will Rhyins, Editor and Publisher
568 Broadway, Suite 605A
New York, New York 10012
(212) 219-0993

The Workbook
The National Directory of Creative Talent
940 North Highland Avenue
Los Angeles, California 90038
(800) 547-2688

The Creative Black Book
MeShel Reidel, Listings
115 Fifth Avenue
New York, New York 10003
(212) 254-1300

Index

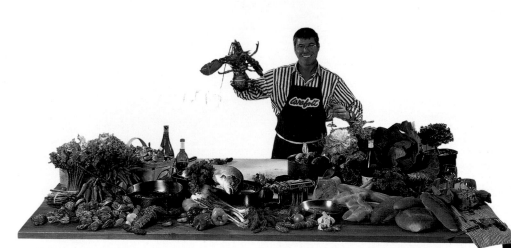

John F. Carafoli is a food stylist based in New York City and Boston. He began his design career in Chicago as a creative and art director for advertising agencies and such magazines as *Sphere* (later known as *Cuisine)* and *Playboy*. During this time, he won many awards for his concepts in graphic design.

Carafoli studied with Madeleine Kamman and other professional chefs, cooks, and food stylists, then began writing and styling feature stories about food for *The Boston Globe.* His writing and styling have since been featured in such magazines as *Bon Appétit, Better Homes and Gardens* (magazine and cookbook), *Ladies' Home Journal, Prevention,* and other publications from Rodale Press. For the past several years he was food editor for *New Choices* magazine.

Some of his recent still life and television accounts include Minute Rice, Knox Gelatin, Pepsi, McDonalds, Ocean Spray, Pepperidge Farm, Howard Johnson's, Mrs. Filberts, New East Rice, and Ground Round.